IMAGES
of America

ROCKFORD

Bobbi Schirado

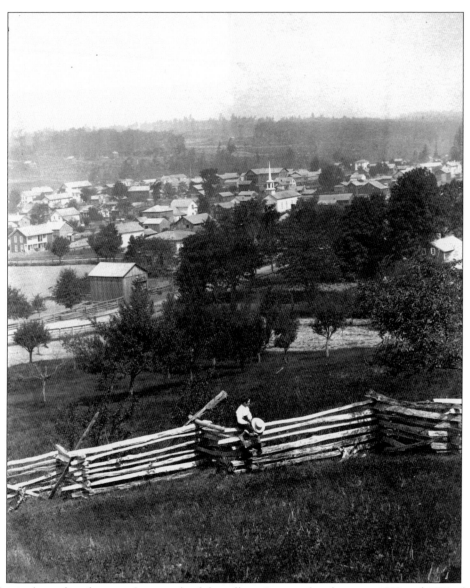

This is the earliest known photograph of the village. It was taken between 1872 and 1878 after Laphamville was renamed Rockford. The view looks northwest from Hyde's Hill over the town and past the Rogue River to recently logged hills in the distance. The large building with the balcony beyond the church steeple was the Stinson House, a major hotel. It was completed in 1867, but like the other buildings on Courtland Street, it was destroyed in the fire of 1878. The church building with its elegant steeple was built in 1872. The boy is unidentified. (Rockford Area Historical Museum.)

On the cover: Decker's Rockford Band was established in the 1870s. This photograph was taken about 1905. The uniform caps have the initials DRB. From left to right are (first row) Will Chapman and two unidentified men; (second row) Judson M. Spore, William Teesdale, ? Decker, and Franklin Jessup; (third row) Clarence Van Dusen, unidentified, Barton B. Hunting, Henry Hessler, and unidentified. (Rockford Area Historical Museum.)

IMAGES
of America

ROCKFORD

Roberta H. J. Schirado on behalf of
the Rockford Area Historical Society

ARCADIA
PUBLISHING

Published by Arcadia Publishing
Charleston SC, Chicago IL, Portsmouth NH, San Francisco CA

Printed in the United States of America

Library of Congress Control Number: 2008943137

For all general information contact Arcadia Publishing at:
Telephone 843-853-2070
Fax 843-853-0044
E-mail sales@arcadiapublishing.com
For customer service and orders:
Toll-Free 1-888-313-2665

Visit us on the Internet at www.arcadiapublishing.com

This book is dedicated to Pat Frye, Rockford Area
Historical Museum director. Her love of local history and genealogy
made working with her an absolute joy. Pat's willingness to go the extra
mile and check with "just one more person" cannot be overstated.
This project is richer for her help and knowledge.

CONTENTS

ACKNOWLEDGMENTS

It is only with the generous support of citizens who donated photographs and historical materials that this book was possible. Many volunteers actively preserved the history of Rockford over the last 80 years. Notable local historians were Bert Coon, Homer Burch, Clarence Blakeslee, and Susie Fair. They worked to discover, interpret, and record the town's past. Without them, much of the area's history would have been lost. Members of the Rockford Area Historical Society have been incredibly generous, giving of their time, talent, and knowledge. Current officers and committee members Terry Konkle, Vic Matthews, Carla Bradford, Jack Bolt, Betty Combs, Janette Konkle, Carla Blandford, Kathy Christensen, Pat Frye, Kathy Cornwall, Janet Matthews, and Joyce Torrey provided assistance and support. Jennifer German, director of the Krause Memorial Library, and Lois Lovell, director of the Sparta Township Carnegie Library, allowed me to make presentations about this book and request photographs and information from the public. Pat Frye, Rockford Area Historical Museum director, and Janet Matthews, archivist, spent hours helping me locate pictures and unravel confusing facts. Individuals who opened family albums or brought in photographs for scanning include Leigh Paull, Terry Konkle, Jack Bolt, Ann Kubiak Milanowski, Helen Kies Uren Hessler, Diane Uren Skiever, Barbara Ammerman Stevens, Noreen Norman Elkins, and Vance Harger. Sue Irvine and Susanne Carpenter of the Plainfield Historical Commission steered me to new sources. The Western Michigan Genealogical Society (WMGS) Web site and databases and the Kent County GenWeb site were invaluable in finding information on individuals, businesses, and organizations. The WMGS Writer's Group kept me on track and excited about the project. Special thanks go to Sue Osgood, Gail Snow, Sr. Michael Ellen Carling, OP, Graham Hollis, Mary Rasch Alt, and Janet Jensen. A special thank-you to my supportive husband for his patience, feedback, and encouragement.

INTRODUCTION

The river was here first. It raced down channels formed by bulldozing glaciers. The newly created stream battered down natural barriers to join a larger waterway flowing into Lake Michigan. This larger river was a truly grand sight, and that is exactly what the first explorers named it—the Grand River. Government surveys to record the Grand River and its northern tributaries began in 1837. James A. Morrison was a member of that survey party. He named the first tributary. Wishing to honor his home in southeastern Michigan, he intended to call the river Rouge, but misspelled it Rogue in his notes. Spelling and pronunciation confusions were finally settled in 1953 by the United States Board of Geographic Names in Washington, D.C. It declared Rogue to be the official name.

Rogue is far more fitting as the river more often resembles a rascal or scalawag than a rosy blush. It has breached its banks numerous times since white settlers Merlin and William Hunter first built permanent structures along its banks in 1843. They were the first to begin taming the river by damming it. They may have been the first settlers to arrive, but by 1850, both had moved north to Newaygo County.

Smith Lapham and other early settlers who arrived in the 1840s remained to cut timber or farm the fertile soil. Lapham was the first to build a sawmill on the eastern bank of the Rogue River. He was a forward-thinking, determined man. For 20 years, until after the end of the Civil War, the village was called Laphamville. At that time, the name was changed to Rockford. The first extant photographic image of Rockford was taken between 1872 and 1878. A split rail fence rests in the foreground at the top of a hill overlooking the village.

A number of pioneers helped create Rockford's history. Russell L. Blakely was the town's first doctor. Other physicians were Dr. Charles Holden, Dr. De Witt Burch, Dr. Hollis O. Sarber, Dr. Edwin B. Strong, Dr. Gerald De Maagd, and Dr. Louis Ferrand. Albert L. Pickett came to the area about 1845 and lived there until his death at the age of 102.

In 1905, the Rogue River went on a rampage and swept away the last remaining sawmill. Local citizens determined to strengthen and improve the dam. They replaced the old wooden base and the spillway aprons with poured concrete. By 1920, the entire spillway structure was remade using concrete and extended farther than ever before. It provided hydroelectric power to residents and businesses until the 1960s.

Over the years, Rockford's downtown district was ravaged by fire several times. One historic brick building withstood repeated flames. It now houses the Corner Bar and its famous hot dog–eating contests. Following its successful survival, almost all rebuilding efforts utilized brick instead of wood. Most of those structures continue to line Main Street.

As Rockford grew, there came a need for bridges to span the Rogue. Horses, trains, and cars required access. In 1928, a truck attempted to cross the bridge on Bridge Street. Weakened in

the 1905 flood, it collapsed under the weight of the truck. A new bridge was completed in 1929 and still stands today.

The Burch Body Shop is the oldest manufacturing company still active in Rockford. It began in the late 1800s as the company that built the Rockford Wagon, a highly desirable lightweight conveyance. Early in its history, it was known as the Haner and Haskell Wagon Works. In 1912, Charles Haner retired and William J. Haskell's son-in-law, Henry Burch, became a partner. The Burch Body Shop expanded its products to include gasoline-powered vehicles, including bodies for commercial cars, trucks, and buses.

Rockford is surrounded by fertile land, and a major part of its history is connected to farming. However, a second major industry arrived in 1903 when the Hirth Krause Shoe Company expanded its Grand Rapids business to Rockford, taking advantage of the electricity generated by the dam. In the 1920s, it became the Wolverine Shoe Company. For many years, shoe leather was generally made from horsehide. As a by-product of the western Michigan meat industry, pigskin was most often discarded. The Wolverine Shoe Company was the first to develop a process allowing pigskin to be used for footwear. The resulting leather was softer and more comfortable. The sad-eyed canine logo for Hush Puppies footwear is instantly recognizable throughout the world. During the latter half of the 20th century, the company's name changed to Wolverine World Wide (WWW), and it became an international manufacturer.

Education has always been an important part of the community. Smith Lapham's daughter, Amy, was the first schoolteacher. The Union School, built about 1870, used bricks that were made in Rockford. In 1922, a major fire destroyed the building. Its replacement was the first school in Michigan to be built on a single level.

A variety of leisure activities have always been available for both young and old to enjoy. Community-based softball, basketball, and bowling teams were enjoyed by both men and women. Bands and orchestras attracted the interest of both participants and listeners. An opera house was located inside the Hessler Building. Early in the 20th century, the Star Theater let families watch moving pictures. There were also many fraternal organizations for citizens to join.

Community means something in Rockford. Citizens donated money and time to build the library, the Community Cabin, and Camp Rockford. The cabin provided a place for organizations and family reunions to meet. The camp presented an opportunity for Boy and Girl Scouts and Campfire Girls to enjoy the outdoors.

Many men represented Rockford in the armed services. Two notables are John C. Sjogren and Clarence Blakeslee. John C. Sjogren received the Congressional Medal of Honor for courage above and beyond the call of duty in the South Pacific during World War II. Clarence Blakeslee wrote a well-received memoir of his experiences on the World War II European front. Women who kept the home fires burning during World War II created a quilt nicknamed the "Bomber Quilt." It has a series of horizontal stripes with an airplane located in the center. The quilt was raffled off and the proceeds donated to build a bomber.

There are many distinguished names in the history of Rockford. Succeeding generations of the Krause family steered the Wolverine Shoe Company to profitability. For a number of years, Gerald R. Ford represented the area in the United States House of Representatives. He later became the president of the United States.

This book is not intended to be a comprehensive history of Rockford, as it was dependent upon the number and quality of the images available and limited in space. Instead, it is an attempt to preserve and provide a visual overview of the people, places, and businesses that make up the community. The author and the Rockford Area Historical Society hope readers enjoy this photographic account of those who built this place we call home.

One

THE RIVER AND
THE TOWN

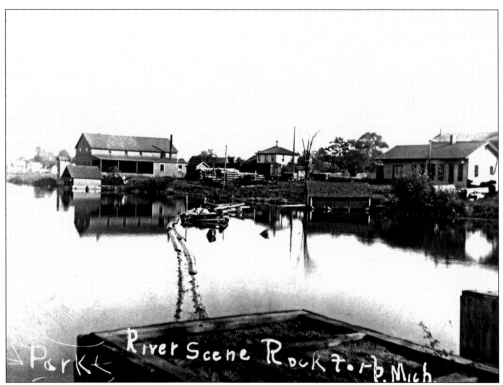

In this early photograph of the millpond, the Dockeray Lumber shed is the large building on the left, and the railroad depot is on the right. The last log drive down the Rogue River in 1902 portended the end of the sawmills. The square white house in the background belonged to Smith Lapham. It was later moved to Lewis Street. The picture was taken from the top of the dam facing north. (Terry Konkle.)

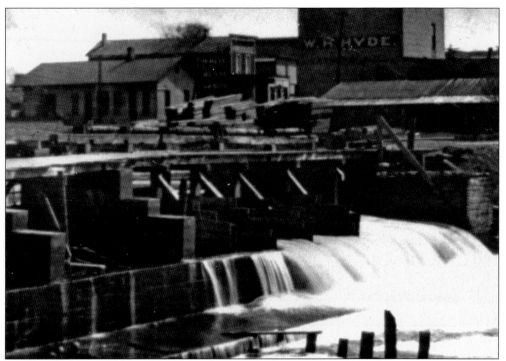

The first dams on the Rogue River were all constructed using wood. This dam was destroyed in the flood of 1905. In the background are stacks of milled lumber, the railroad station on the left, and a sign on the side of a building advertising "W. R. Hyde Green Grocer." (Rockford Area Historical Museum.)

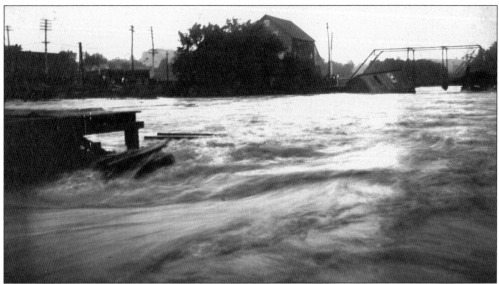

The Rogue River repeatedly lived up to its name. The flood of 1905 created a great deal of havoc. The raging waters of 1905 completely washed away the dam's wooden spillway (weakened by previous high water in 1904), carried away the tower of the electric lighting plant, and destroyed the Tabor and Watkins Sawmill. Owned by Edward L. Piper, this was the last remaining sawmill in Rockford. (Rockford Area Historical Museum.)

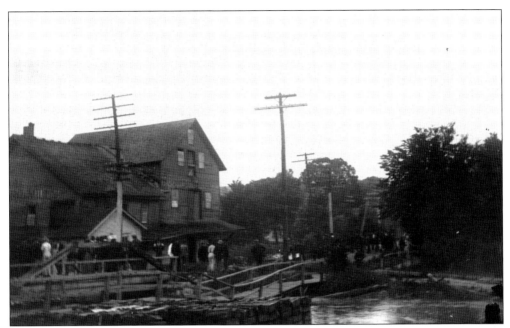

The flood of 1905 attracted numerous spectators. This picture was taken while the iron bridge was still threatened and before the old mill was dynamited. On the left is the old wooden highway bridge that spanned the canal. A wooden walkway sags into the water to the right of the bridge. The iron bridge in peril can be seen in the distance. (Rockford Area Historical Museum.)

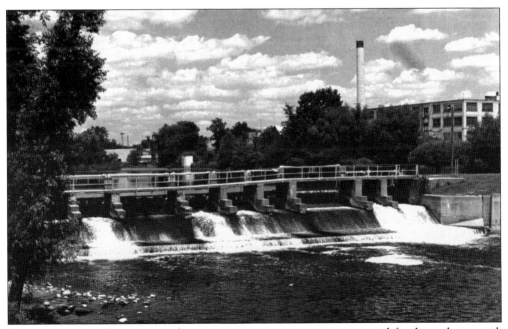

Concrete is a much stronger and more permanent construction material for dams than wood. The photograph above was taken during the late 1940s or early 1950s. A concrete walkway allows individuals to safely view the Rogue River. The millpond and the Wolverine Shoe Company building and its smokestack are in the background. (Rockford Area Historical Museum.)

Rockford

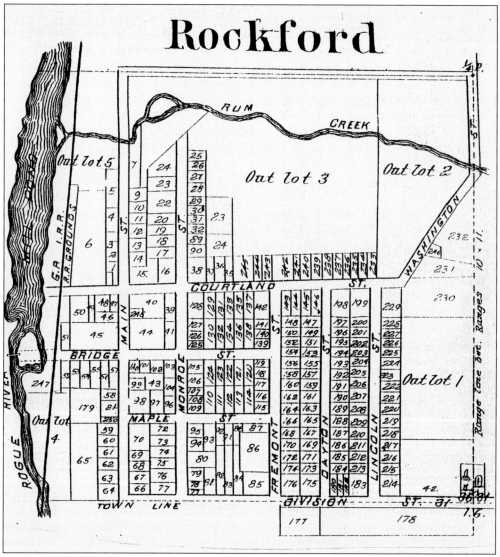

This 1866 map of Rockford was replatted by Volney Caulkin. While the town has continued to expand, the basic layout has not changed in over 150 years. All the street names are the same with the exception of Washington Street. It is now a section of Northland Drive. Just as in 1866, the downtown business district continues to be located on Main, Courtland, and Bridge Streets. However, the small island in the river no longer exists. The canal on the island's right was filled in and is now part of the park surrounding the dam. (Rockford Area Historical Museum.)

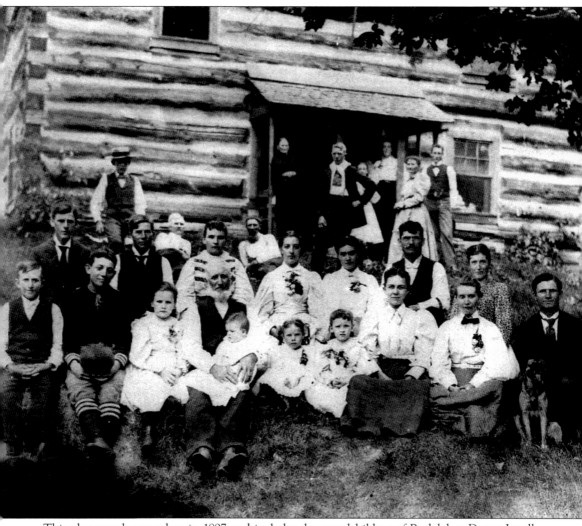

This photograph was taken in 1897 and includes the grandchildren of Rodolphus Dewey Jewell. Seated are, from left to right, (first row) an unnamed Dockeray boy, Harry DePew, Hazel Jewell, Rodolphus Dewey Jewell, Agnes Jewell (in her grandfather's lap), Reva Dockeray, Bessie Jewell, Edna Clark, Alta Dockeray, and Jim Jewell; (second row) Dewey Jewell, Archey Dockeray, Clara Jewell, Hattie Hale, Millie Grove, Harry Jewell, and Etta Denton. Those seated or standing behind the first two rows are not identified specifically but include Claude Allen, George S. Jewell, Clarence Dockeray, Edna Clark June, Hazel Jewell (Mrs. Carl Squires), and Agnes Jewell (Mrs. Wayne Zimmerman). The picture was taken on the northwest corner of Eleven Mile Road and Summit Avenue. (Rockford Area Historical Museum.)

James F. Judson used his knowledge of waterpower to establish an operational gristmill in 1857 on the east bank of the Rogue River just south of Smith Lapham's mill. Judson first built a small cabin and then in 1862 completed the large Italianate Victorian home seen above. The house continues to overlook the Rogue River from a high hill on the west bank of the river. (Rockford Area Historical Museum.)

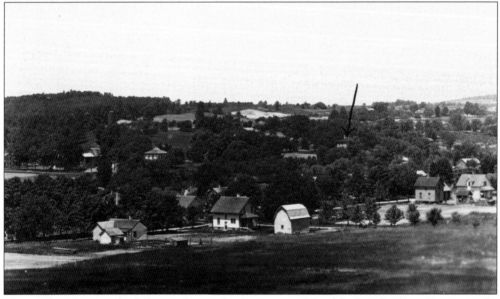

This early-1900s postcard shows the southern section of Rockford with Main Street in the foreground. The back says the arrow points to the Judson house. Unfortunately, the name of the person the writer addressed is missing. The row of small trees in the bottom right third of the photograph are recently planted maples along Ogden Street. (Terry Konkle.)

When virgin timber was removed, only tree stumps remained. Those stumps had to be pulled before the land could be turned by a plow and planted. Once the stumps were out, many farmers used them to keep livestock from wandering. The picture above was found on a postcard mailed in 1924. The card states, "Famous Stump Fences, Rockford, Mich." (Rockford Area Historical Museum.)

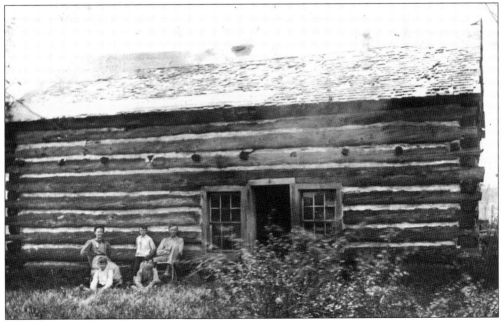

Settlers in the 19th century found abundant forests that were useful in building sturdy log homes like the Simmons house seen above. Seated on the ground are brothers Erval (left) and Forrest Simmons. Seen behind them are Nina, Lyle, and Fred. Fred A. and Nina P. Simmons were married in 1893. This photograph was taken around 1910. The cabin was located on Eleven Mile Road, west of the Pitch farm. (Rockford Area Historical Museum.)

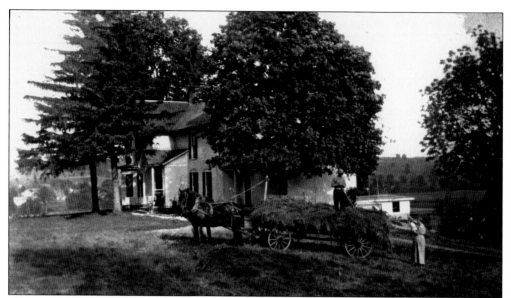

Raising livestock required growing grain and hay. Even as late as 1923, horses did most of the day-to-day hauling. The house in this photograph belonged to Elwin Giles and is located on the corner of Division (Ten Mile Road) and Oak Street. The farm had a large barn and several outbuildings. (Vance Harger.)

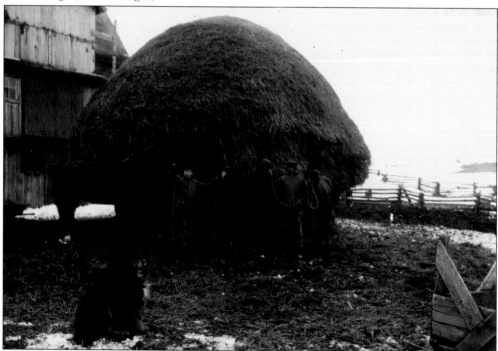

During the late 19th and early 20th centuries, haymows were a common sight on farms. Loose hay was piled high to sustain livestock through snowy winter months. As animals ate around the base of the mow, hay would fall to the ground making it easier to reach. This photograph was taken in 1912. Ed Whittall is on the left, and Wayne Whittall is on the right. (Rockford Area Historical Museum.)

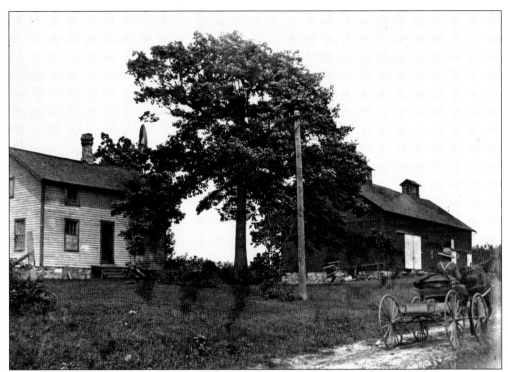

The photograph above is of Wesley Hessler's farm on Eleven Mile Road. With his brother, Henry, Wesley built the Hessler Building on Main Street. The image below was taken in 1938. Mechanical horses never tired and soon supplanted those with hooves. This is an Aultman-Taylor steam traction engine built before 1924. It was owned by Leonard Ingraham and Joe Caldwell. An unidentified man is pictured on the left with Ingraham in the center and Caldwell on the right. The Aultman-Taylor Company was bought out by Advance-Rumely, and then the combined company was purchased by Allis-Chalmers. By 1950, most farmers had converted to using tractors manufactured by larger companies such as John Deere, Ford, Massey-Ferguson, and Allis-Chalmers. (Rockford Area Historical Museum.)

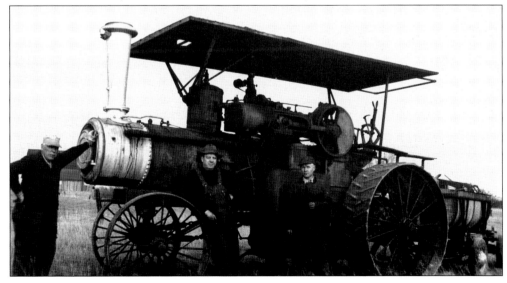

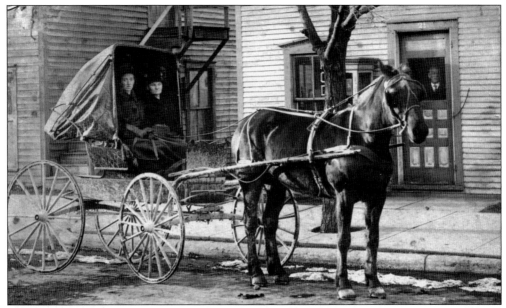

Travel in the 19th and early 20th centuries was usually dusty and bumpy. A buggy like the one above was a common sight in Rockford. The canopy helped keep out the hot sun or protect riders from rainstorms. Here Emma Whittall holds the reins on the left, and Blanche Whittall sits next to her. Doty is the horse. (Rockford Area Historical Museum.)

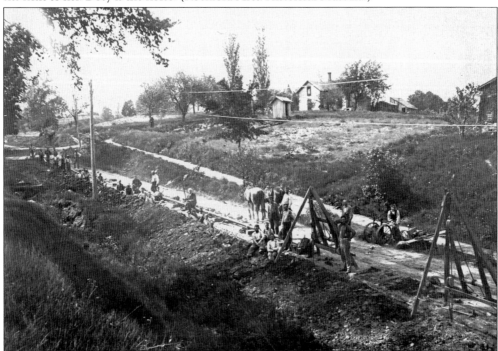

These workmen are laying the new water main on Summit Street. The method and equipment used is quite different than that used today. The rocks and soil were mainly moved by manual labor. Around 1900, when this picture was taken, horses provided any extra power needed, not motorized trucks and bulldozers. (Rockford Area Historical Museum.)

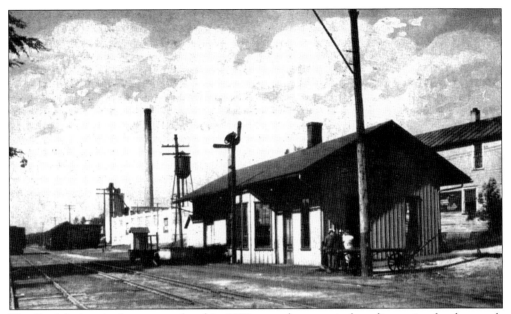

The Rockford train depot, completed in 1878, served as a main boarding point for thousands of travelers. It was a stopping point for the Grand Rapids and Indiana Railroad. It was replaced by a new, smaller building in the 1940s. Looking north beyond the depot, the Wolverine Shoe Company smokestack and water tower stand above the town. (Jack Bolt)

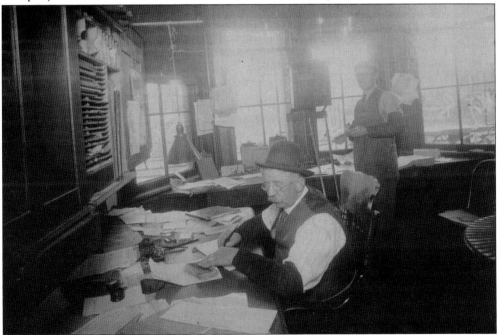

Henry Sheets was born in Ohio, and he married his wife, Alice, in 1889. Above he is seen working as a telegraph operator in Rockford around 1900. By 1920, he was an agent for the Grand Rapids and Indiana Railroad. Altogether he worked for the railroad almost 50 years, from 1881 until he retired in 1929. Sheets also served as village president. Everett Betts stands in the background. (Rockford Area Historical Museum.)

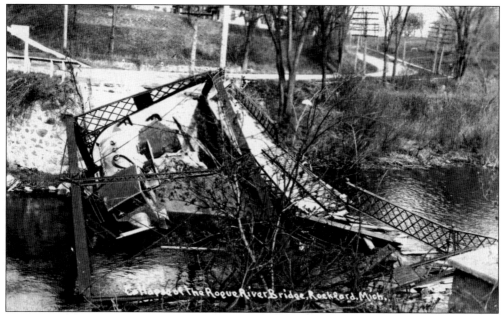

During the 1905 flood, the last sawmill building lodged beneath the iron bridge that crossed the Rogue River connecting Rockford to Algoma Township. Dynamite was used to blast the rubble away from the bridge, but a great deal of twisting and humping had damaged the structure. On May 4, 1928, Herbert Stacey drove his small Mackinaw Trail Oil Company tank truck onto the west end of the bridge when the bridge collapsed. The roadway and the front end of the truck landed in four feet of water. Herbert's wife, Edith Omelia Runnels Stacey, was severely injured. Herbert was unhurt. On May 7, the state highway department authorized a new concrete bridge at a cost of $30,000. The new bridge, seen in the photograph below, was completed in December 1928. That bridge still stands just below the dam on Bridge Street. (Rockford Area Historical Museum.)

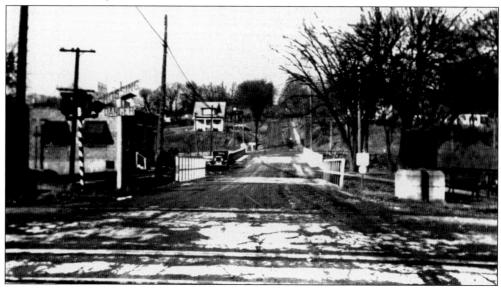

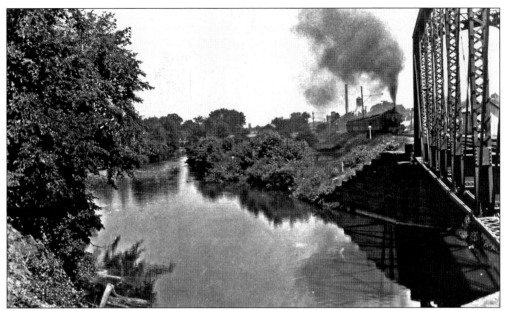

In 1899, a new Grand Rapids and Indiana Railroad bridge was constructed over the Rogue River below the dam and millpond. It took trains, like the one above, south to Childsdale and then on to Grand Rapids. The Bridge Street bridge can just be seen upriver. (Jack Bolt.)

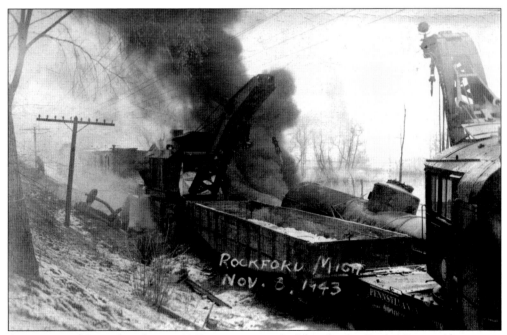

On a snowy November day in 1943, a train wrecked beside the Rogue River. Above, two mechanical cranes are trying to put a damaged oil tank up on the flatcar. The wreck occurred in back of the homes of a Mrs. Matthews and George Platt. The Platt home was located next to Wilbur Browning's house. All three are located on the west side of Main Street across from the old high school. (Rockford Area Historical Museum.)

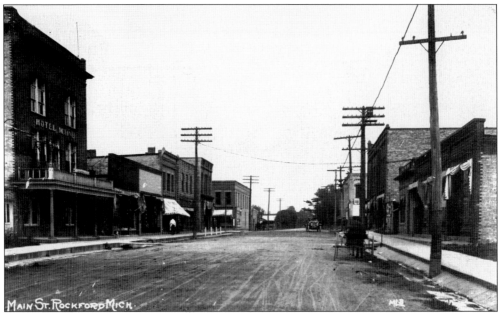

Main Street has been the heart of Rockford's business district almost since the inception of the town. The photograph above was taken around 1900, while the image below was shot around 35 to 40 years later. Both look north from Bridge Street. The type and amount of traffic increased over time. Around 1900, the tall building on the left was the Hotel Maine. In the later picture, the same name is still vaguely visible on the side of the building, but the neon sign in front declares it is now called the Rockford Hotel. (Rockford Area Historical Museum.)

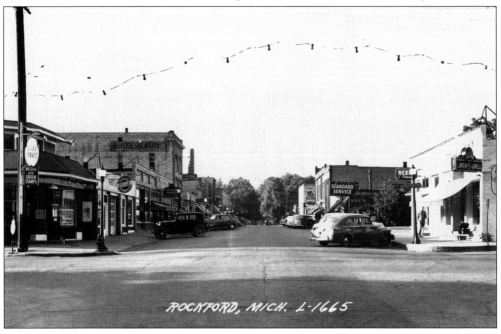

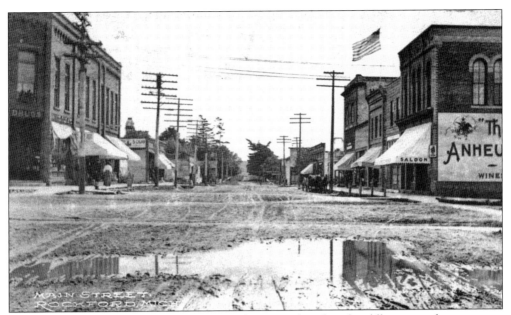

In the photograph above, Main Street has not been paved, and mud puddles were rather common. This picture was taken just north of Courtland Street looking south. Two tall remaining virgin pines can be seen far down the road. The flag on the right side of the street is flying over the post office. This view is from around 1900. (Terry Konkle.)

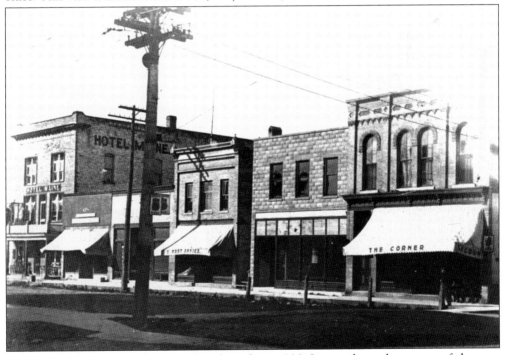

Like the picture above, this view was taken about 1900. It provides a closer view of the west side of Main Street. The awning on the right side advertises "the Corner" and "Saloon." This building survived the disastrous fire of 1896. After that fire, almost all buildings on Main Street were built using bricks. (Rockford Area Historical Museum.)

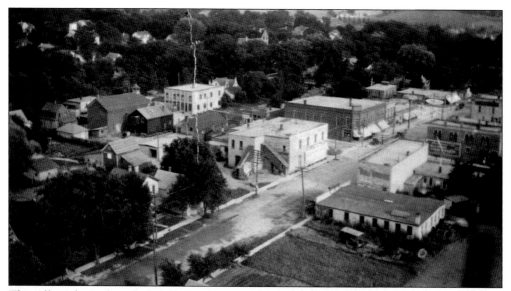

The tall smokestack at the Wolverine Shoe Company provided an overview of Main Street in 1920. By that time, cement sidewalks had been built on either side of the street. Rockford has always had an abundance of trees adding to its ambiance, and this image shows how many and how beautiful they were. (Rockford Area Historical Museum.)

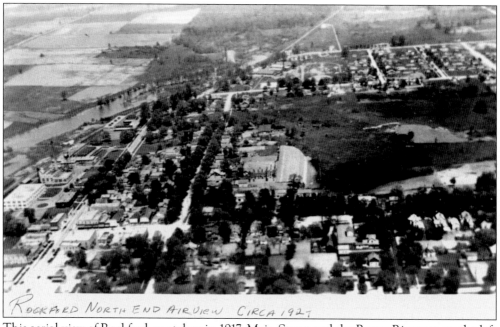

This aerial view of Rockford was taken in 1917. Main Street and the Rogue River are on the left side of the picture. The large buildings near the river are those of the Wolverine Shoe Company. The fields in the upper left illustrate the continued importance of farming to the area. (Rockford Area Historical Museum.)

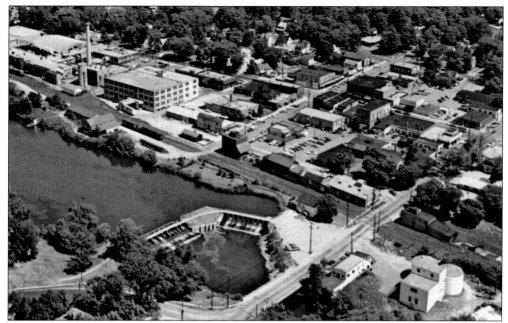

This is a much more recent aerial view of Rockford taken in the 1970s. It delineates both the similarities and changes that occurred since the dawn of the 20th century. The "double dam" is now a fixture in the landscape. It controls the Rogue River and protects the town from possible flooding. (Jack Bolt.)

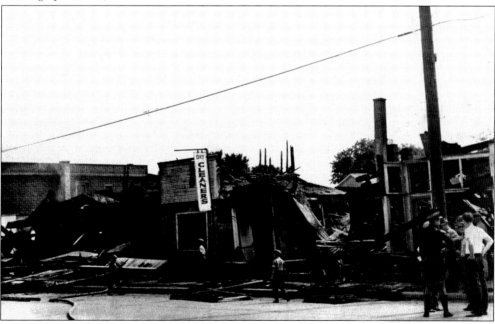

Rockford suffered through a number of devastating fires. After disastrous fires in 1878 and 1883, it still took years before public opinion demanded a municipal water system. Work still had not been initiated when a third major fire wiped out most Main Street businesses on April 8, 1896. The picture above shows the results of a fire in the 1930s or 1940s. (Rockford Area Historical Museum.)

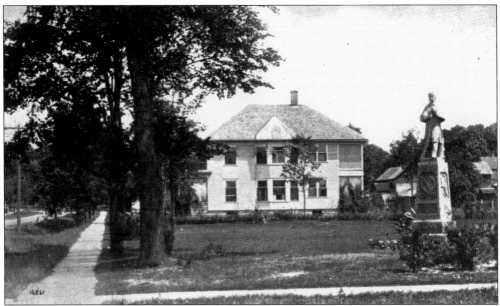

In 1906, a company canvassed the region promoting the erection of memorials to Civil War veterans. Locally a soldiers' monument committee sponsored a successful drive for subscriptions to a purchase fund. The memorial was erected in the Village Park in 1907 or 1908. The old jailhouse was torn down to make room for the park. (Terry Konkle.)

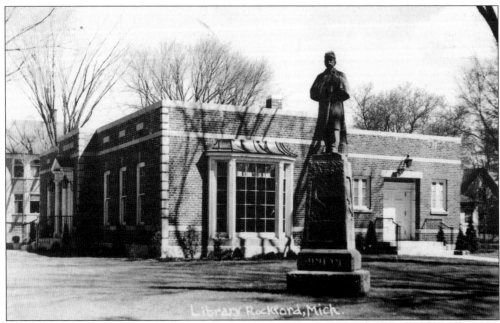

The park in the previous photograph became the home of the Krause Memorial Library in 1937. Gustavus Adolphus (G. A.) Krause, one of the founders of the Hirth Krause Shoe Company, donated more than $20,000 to build a public library in memory of his wife and daughter. His descendants have continued to support the library through expansions and an endowment fund. (Terry Konkle.)

Two

BUSINESS AND INDUSTRY

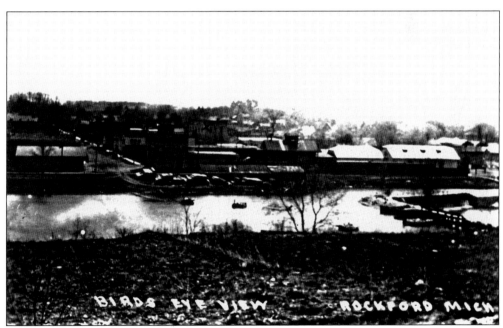

The picture above shows the dam on the Rogue River and the millpond behind it. Taken from the west bank, it looks east up Courtland Street. Boats are docked along the top of the dam. The W. H. Hyde building is located in the center of the photograph, and the railroad station is on the left. (Rockford Area Historical Museum.)

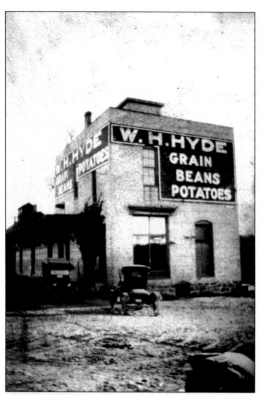

The W. H. Hyde building anchored the corner of Courtland Street and what is now Squires Street. The west side of the building faced the railroad track and the Rogue River. The company worked closely with farmers and growers buying and selling various grains, beans, and potatoes. Toward the end of the 20th century, it was converted to a restaurant. (Rockford Area Historical Museum.)

The building on the left is the Johnson and Loveless building. It was a center for buying and selling produce. Later it became the Dockeray Lumber Yard. The smaller building held DeCommerce Photography and at one time a tailor shop. Eventually it was torn down as the lumberyard expanded. George A. Dockeray sold the lumber business to Walter Robbie in the 1930s. (Rockford Area Historical Museum.)

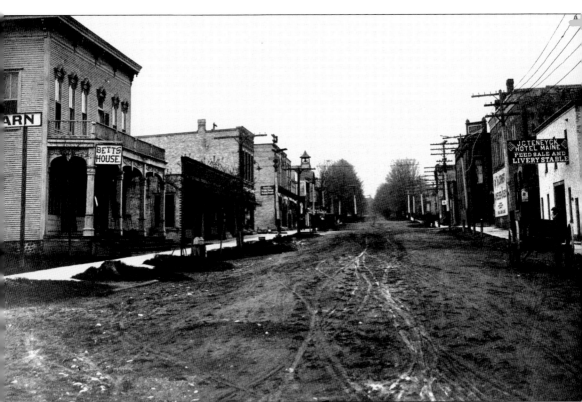

Out of the ashes of the fire of 1878, Embra B. Lapham rebuilt his hotel and named it the Lapham House. Lapham sold it in 1882 to Samuel and Plyna Betts; they changed its name to the Betts House and managed it for the next 40 years. In 1922, J. E. Wonders purchased the hotel. He first changed its name to the Commercial and then to the Wander Inn. He sold once more, and the new owners ran the hotel until about 1936, when the building was razed to make room for the new post office. By 1905, the photograph above shows that Courtland Street had received recently paved sidewalks. The wagon on the right side of the picture sits in front of J. Teneyck's livery stable. (Rockford Area Historical Museum.)

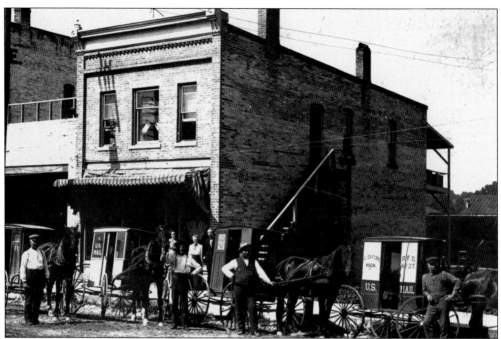

In 1903, rural mail delivery was a novelty. The four mailmen standing beside their wagons are, from left to right, Albert Jewell, L. H. Wilkinson, Mike Potter, and John MacAuley. Standing on the post office steps are, from left to right, Ella Wall, Clara Dunton Spore, and postmaster Judson M. Spore. While postmaster, Spore also sold a small stock of merchandise. (Rockford Area Historical Museum.)

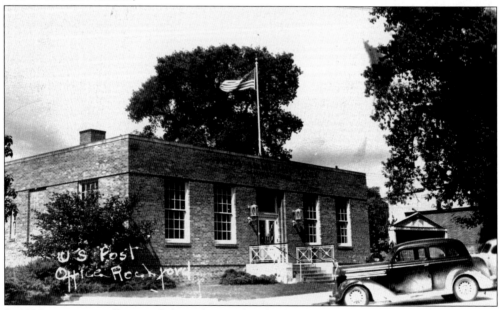

In 1936, a new post office was dedicated in Rockford. The town was growing, and a larger facility became necessary. Before this building was constructed, postal services were located in a smaller building on Main Street. The new post office was built on Courtland Street, where the Betts House hotel once stood. (Rockford Area Historical Museum.)

In the 1900 census, Seymour Hunting was a grocer. In 1910, he and his wife Effie lived on Monroe Street with their daughter Grace and son Clyde. Seymour and Barton were two of the children of Isaac and Sarah Hunting. (Rockford Area Historical Museum.)

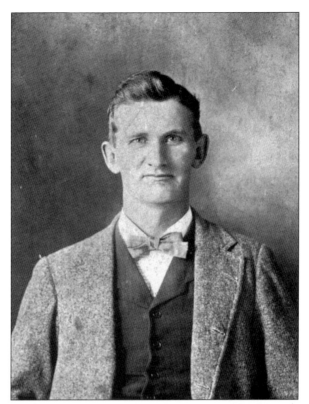

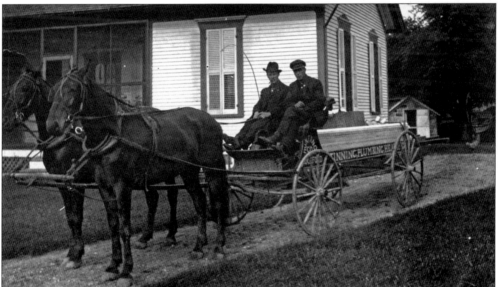

This wagon advertises the "Hunting Company, Tinning, Plumbing, Heating." Lewis M. Hunting and his cousin Barton B. Hunting (see cover) organized the Hunting Company, a hardware and farm implement firm, in 1905. Barton was the inventor of the Hunting Company's well and cistern covers. After several years, Barton B. Hunting left and his brother Seymour took his place. In 1923, Lewis M. Hunting formed the Rockford Plumbing Company. (Rockford Area Historical Museum.)

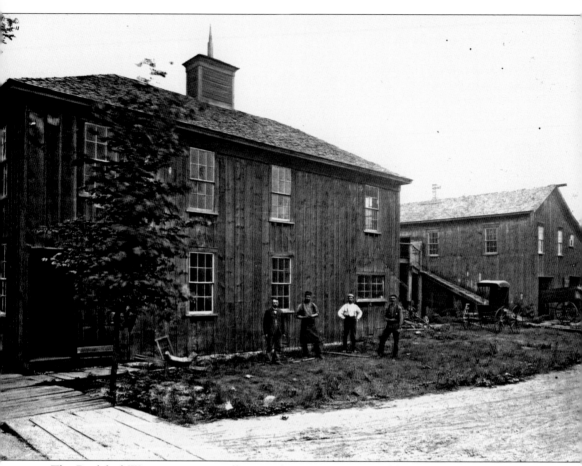

The Rockford Wagon was an excellent product. G. E. Hovey sold many such wagons. About 1873, Charles Haner bought into Hovey's business. During the 1880s, Hovey sold his interest to William J. Haskell and the business became Haner and Haskell Wagon Works. In 1912, Haner retired and Haskell's son-in-law, Henry Burch, joined the firm. The company than became Burch Body Works. Above is the wagon and carriage shop owned by Haner and Haskell on the corner of Bridge Street and Monroe Street. Later the firm moved to North Monroe Street. The four men standing in front of the building are, from left to right, Phillip Kline, blacksmith Mike O'Neil, Charles Skellenger, and Albert "Abb" Teesdale. (Rockford Area Historical Museum.)

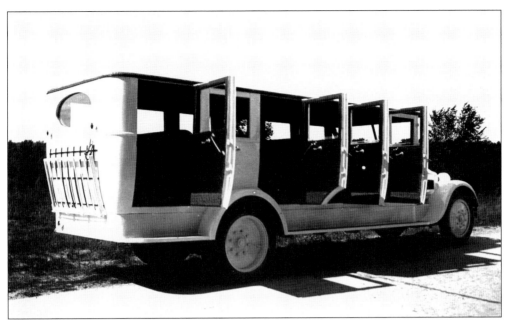

This is a large limousine built by the Burch Body Company. A company saying was "Buy Burch Better Built Bodies." The firm expanded rapidly during the 1920s and 1930s. It continued to be a mainstay in the community, providing jobs for local residents. (Rockford Area Historical Museum.)

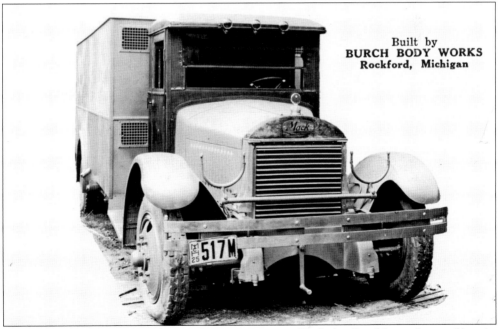

Built by
BURCH BODY WORKS
Rockford, Michigan

This photograph advertises the truck's origin, saying "Body by Burch" on the truck's side. This truck had a refrigerator body and was used to haul perishable vegetables. As well as truck bodies, Burch Body Works built thousands of school bus chassis. Its products have always been dependable and durable. (Rockford Area Historical Museum.)

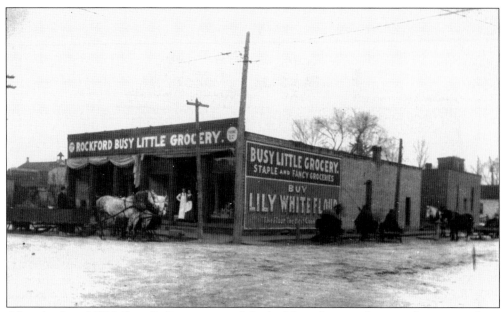

After the fire of 1896, Ross B. Squires erected the building above and operated a grocery there for some years. Subsequent owners were Henry J. and M. Shelton Stowell, Oliver Crothers, and Oscar Casterline. Harry Elhart bought the store in 1909. This photograph shows Charles Ammerman and his team of horses in front of Elhart's Busy Little Grocery about 1910. (Barbara Ammerman Stevens.)

During the 1880s, Ross B. Squires was one of the biggest produce dealers in Michigan. In 1889, he teamed with William H. Hyde. The firm of Hyde and Squires handled some $50,000 annually. In 1895, Ross struck out on his own, with a potato trading station in the Johnson Building. In addition to a grocery store, he built several other buildings on Bridge Street. He married Grace Carlyle in 1896. (Rockford Area Historical Museum.)

The Keech Laundry was located in the Keech home on the west side of Summit Street. A 1904 *Rockford Register* advertisement stated, "Your work respectfully solicited. Collections made Monday morning and Thursday afternoon of each week. Work delivered Thursdays and Saturdays." In the photograph above are, from left to right, Nettie Covey, an unidentified boy, Alick Keech, Rollo Keech, Reba Keech, Mother Keech, Charlie Keech, and E. R. Keech. (Rockford Area Historical Museum.)

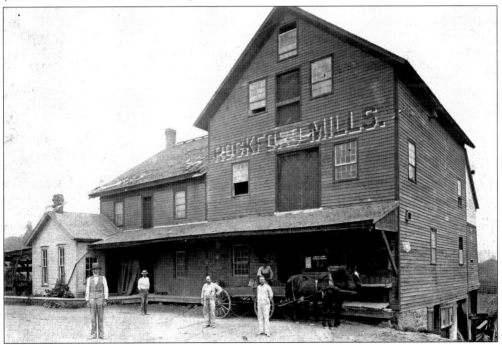

Rockford's first gristmill was built in 1852. In 1894, John C. Smith and his son, Arthur D. Smith, purchased full control in the Rockford Roller Mills. By 1900, the mill pictured above did an annual business of $44,000, grinding wheat, buckwheat, corn, oats, and rye. The four men standing in front are, from left to right, John C. Smith, Arthur D. Smith, Chauncey Porter, and R. Harlow Dockeray. (Rockford Area Historical Museum.)

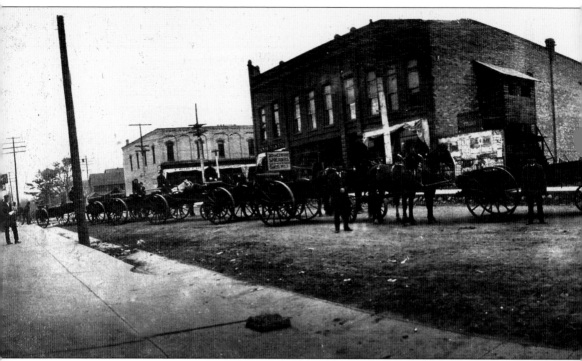

Farmers always appreciate new mechanical inventions. About 1910, the Hunting Hardware Company became the local agent for an innovative, much-needed, and well-received farming implement—the manure spreader. Before the advent of the manure spreader, farmers moved stable refuse using manual labor. It was a tough and dirty job. Getting fertilizer to the fields could now be accomplished more quickly and much easier. When the first shipment of spreaders

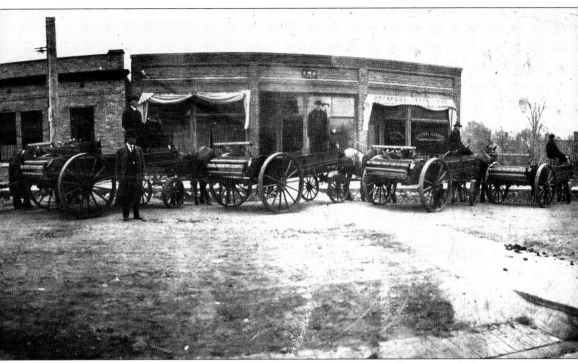

arrived by rail, 12 proud new owners came to town with their teams for a general "drive-away," as an advertising and publicity gimmick. The sign proclaims, "20th Century Spreaders." This panoramic photograph was taken across from the Rockford State Bank in front of the Hotel Maine looking northeast along Main Street. (Rockford Area Historical Museum.)

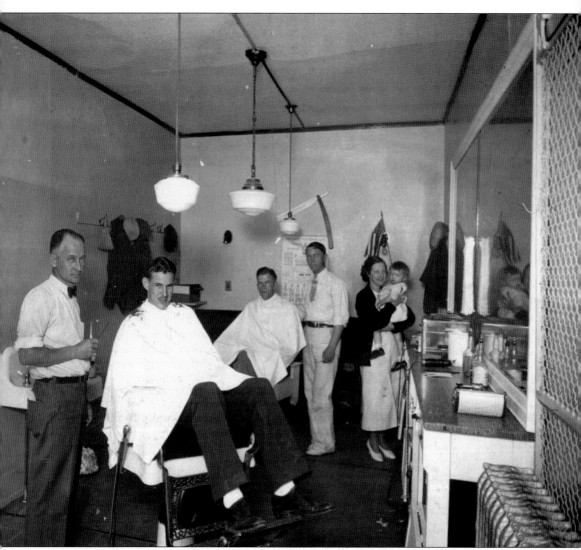

Barbershops, like beauty parlors, were and are a hotbed of information and gossip. A man often recalled his first haircut by someone other than his mother as a right of passage, sometimes fondly, sometimes not so fondly. Barbershops were usually utilitarian in nature with few amenities or decoration. Above is a photograph of Lee Cook's barbershop around 1940. Wayne Bellows is in the front chair, and Les Matthews is sitting in the far chair. Lawrence "Barb" Price is the barber standing in the background. Lee Cook stands in front. The woman and baby are unidentified. (Rockford Area Historical Museum.)

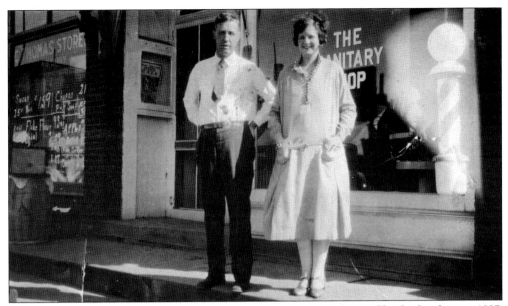

Above, Bob Allen stands with Grace Pauwells Vanden Bos in front of his barbershop in 1927. The shop was located in the Johnson Building storeroom. The grocery store on the left was the C. Thomas store. It was controversial because it was the first in Rockford to offer cash-and-carry, high-volume cut-rate prices. It was also the first chain store to compete with local merchants. (Rockford Area Historical Museum.)

Lawrence "Barb" Price also worked at Newman's Barber Shop. Here he cuts an unidentified man's hair. Note the old-fashioned cash register on the right and the barber pole outside the window. A number of bottles of hair tonic or other products that might make a man more handsome are on the ledge in the background. (Rockford Area Historical Museum.)

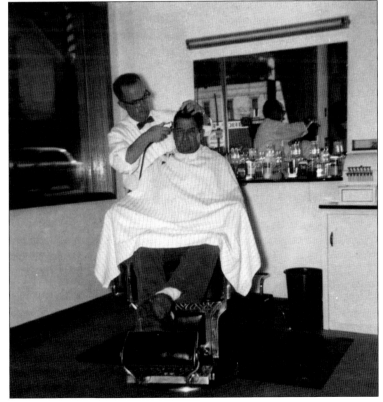

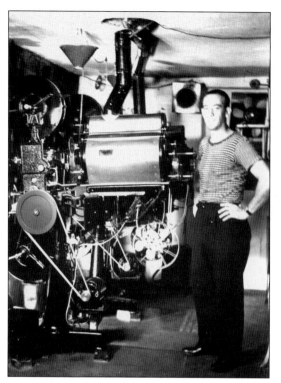

Ardie Elkins worked in the projector room of the Star Theater about 1930. The original Star Theater was part of a 1914 chautauqua program with George Brogger as its proprietor. Rockford residents enjoyed a variety of moving pictures during the next half century. After silent movies came musicals, dramas, and comedies. The 1960s brought *Brides of Dracula*. (Rockford Area Historical Museum.)

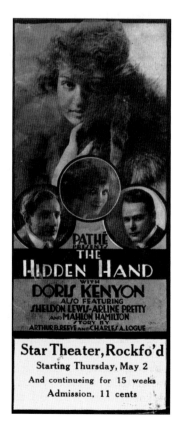

PATHÉ PRESENTS
THE
HIDDEN HAND
WITH
DORIS KENYON
ALSO FEATURING
SHELDON LEWIS-ARLINE PRETTY
AND MAHLON HAMILTON
STORY BY
ARTHUR B. REEVE AND CHARLES A. LOGUE

Star Theater, Rockfo'd
Starting Thursday, May 2
And continueing for 15 weeks
Admission, 11 cents

John and Dorothy Oatley began showing movies on the southwest corner of Bridge and Main Streets in 1924. Later a new 440-seat Star Theater was built behind the Sears-Coon store. In 1964, Dorothy sold the building. It was demolished to make room for a parking lot in the late 1990s. On the right is a photograph of a Star Theater program featuring the Pathé movie *The Hidden Hand*. (Rockford Area Historical Museum.)

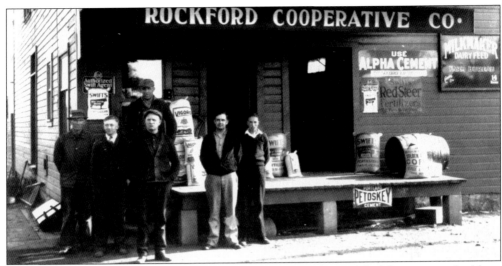

This photograph was taken in the late 1920s or early 1930s. The Rockford Co-operative building, also known as the Red Warehouse, was erected by Grand River steamboat captain Alfred X. Cary in 1868. The building still stands at 30 East Bridge Street. George Bratner stands behind, from left to right, Frank Paepke, Audley Whittall and manager Charles Turner and his sons Myron and George. (Rockford Area Historical Museum.)

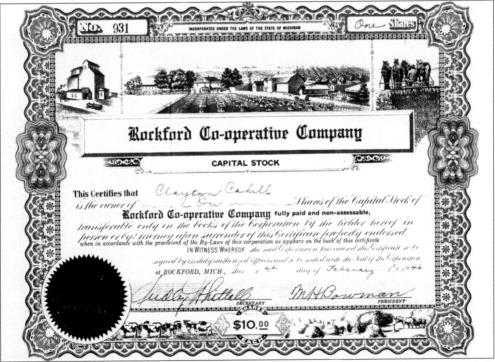

This Rockford Co-operative Company stock certificate is made out in the name of Clayton Cahill. The cooperative was founded in 1920 and remained in existence for over 30 years. The cooperative was started and owned by local community members. Swifts's fertilizer, Alpha and Petosky cement, Milkmaker dairy feed, coal, and other useful products for both farm and home were available to cooperative members at a reduced cost. (Rockford Area Historical Museum.)

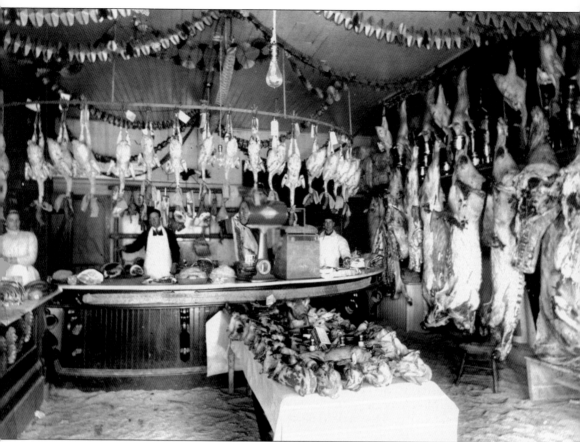

This photograph of the A. J. Blackburn and Company meat market was used in a February 23, 1911, advertisement. Arthur J. Blackburn opened his shop in Rockford in 1902. Born in 1877 in Charlotte, Michigan, he moved as a small child to Coral. As a young man, he joined his father in the meat business in Sand Lake. There he met Christie Rice and married her on December 24, 1901. He operated Rockford's meat market until 1918 when he sold it to Frank Randell. The Blackburns then moved to a farm near Sand Lake. In 1938, the couple bought the Edgerton store. They operated it until 1947, when they moved back to Rockford. Arthur died in 1953, and his wife, Christie, died in 1954. They were survived by their daughter Merritt Newell of Rockford and grandson George Newell of Grand Rapids. (Rockford Area Historical Museum.)

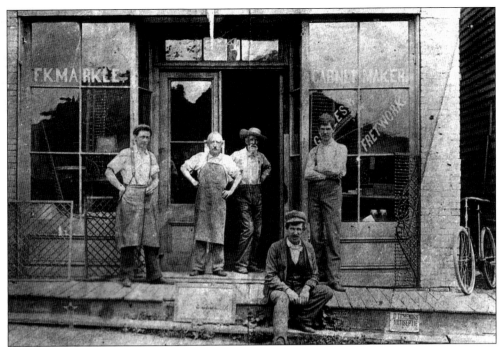

Frederick Kirby Markle was a carpenter by trade. He married Vena Backer, daughter of Reclad Backer. His store window advertises that he did gables and fretwork and made cabinets. Fretwork is often used as gingerbread, the decorative designs cut out with a fretsaw or jigsaw that adorns trim around gables. Most fretwork patterns are geometric in design. This photograph was taken around 1890. (Rockford Area Historical Museum.)

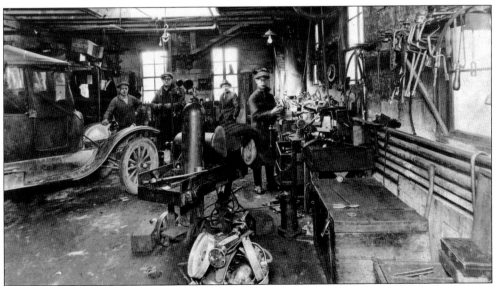

In 1931, Chuck Truax followed the lead of an earlier mechanic, Seeley Clark, and opened his own garage business. Some 10 years later, he purchased the building on Main Street north of Courtland Street where a car repair business still exists. In 1947, Truax purchased the Pontiac franchise from General Motors and became a car dealer. (Rockford Area Historical Museum.)

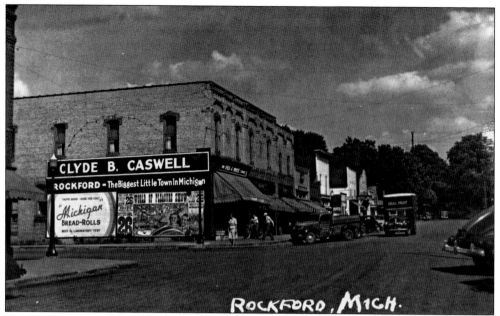

For many years, Rockford billed itself as the "Biggest Little Town in Michigan." This sign is on the side of the Red and White store building on the northeast corner of Main and Courtland Streets. The sign also advertises the World of Pleasure carnival and Michigan Bread and Rolls. (Rockford Area Historical Museum.)

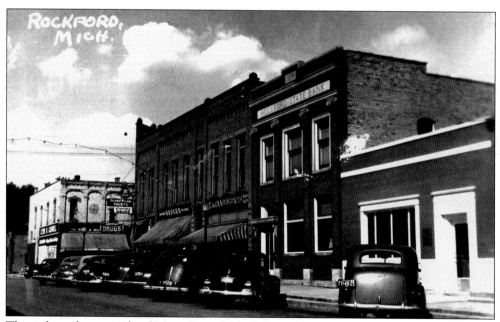

This is how the east side of Main Street looked during the 1930s and 1940s. At the far right is the Bell Telephone building. Continuing up the block are, from right to left, the Rockford State Bank, the Kraas five-and-dime, the Kroger grocery store, and Stanfield's drugstore. The Red and White store can be seen on the other side of Courtland Street. (Rockford Area Historical Museum.)

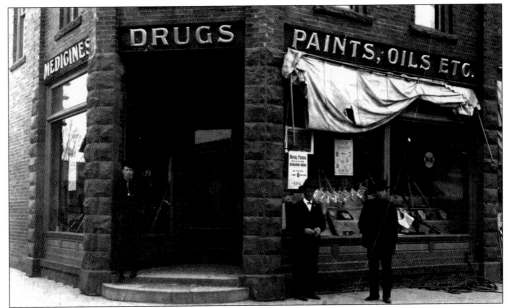

The Hessler Building is located on the southeast corner of Main and Courtland Streets. It was built in 1899 by Wesley Hessler and his brother, Henry Hessler, after a devastating fire that leveled most downtown buildings. It was constructed of bricks and is 71 feet by 84 feet in size. Wesley owned the pharmacy and his brother Henry owned a hardware store to the right of the drugstore. (Terry Konkle.)

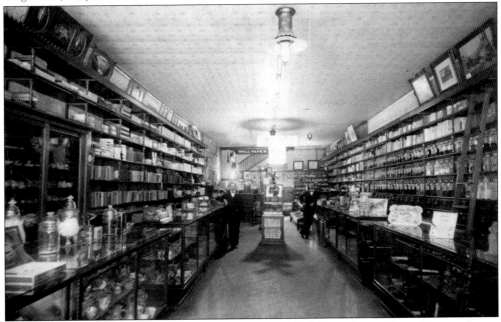

The Hessler Building housed the Hessler Pharmacy and Drug Store. This photograph was found in a garage at the former home of Wilbur Browning. On the back was written, "This is how we look," with the name "Will B.," for Wilbur Browning, who is standing on the left side of the photograph. He was one of the first telephone operators in Rockford. (Rockford Area Historical Museum.)

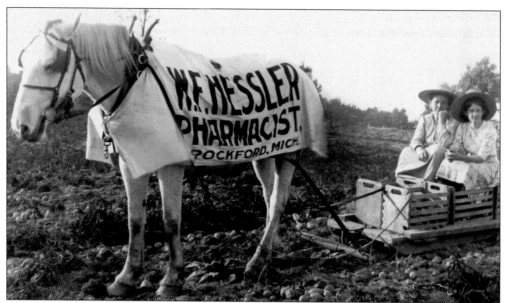

Advertisers in the early 20th century needed to be creative. Wesley Hessler decided a movable sign could be seen by more potential customers. The two young women are riding on a potato sled. Potato pickers would lean down, grab the potatoes, and put them in the crate at the front of the sled. This photograph was taken on the Wooster farm on Young Road. (Rockford Area Historical Museum.)

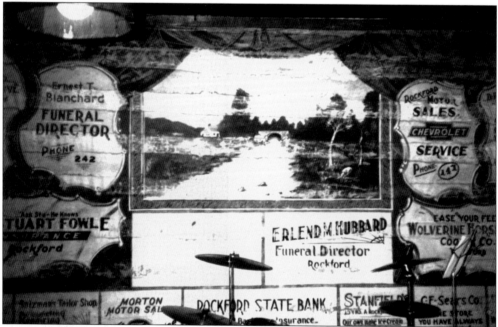

The opera house was on the second floor of the Hessler Building. It had a permanent stage with dressing rooms on either side. There were three background curtains: the first was painted with an elaborate scene, the second (shown above) was a street scene with advertisements for local businesses, and the third showed a woodland scene. The curtains were painted by the celebrated scenic artists Sosman and Landis. (Terry Konkle.)

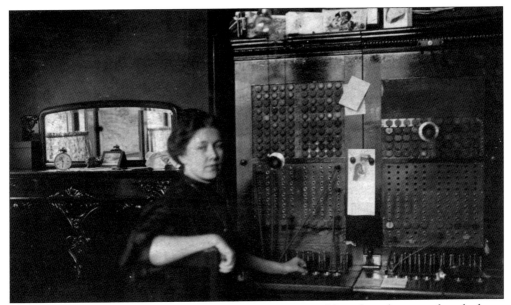

Blanche Hessler sits in front of the imposing intricate switchboard used to transfer telephone calls in the early 1900s. Rockford's first telephone answering center was located in the Hessler Building on the second floor above the pharmacy. Later the operators were moved downstairs next to the back wall of the drugstore. (Rockford Area Historical Museum.)

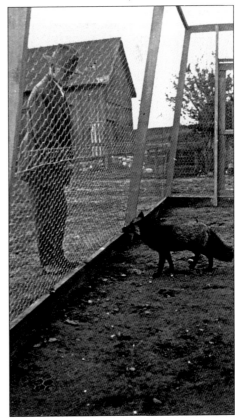

The farm on the corner of Division Street and Oak Street owned by Charles Giles had more exotic livestock than the average dairy farm. Fur farming could be a lucrative business. At one time, there were over 70 silver foxes in residence. In the photograph at right, Giles and a vixen make eye contact. (Vance Harger.)

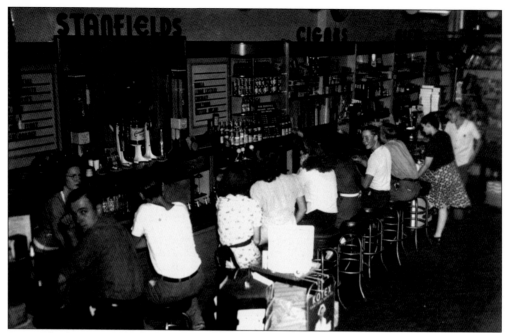

Reva Charles Stanfield Sr. purchased the Hessler Pharmacy and Drug Store in the 1920s. Stanfield's Drugs then became a fixture on Main Street for many years. In 1930, the Stanfield family lived at 119 Monroe Street. During the 1940s, teenagers flocked to the soda bar, and it became a favorite hangout. (Rockford Area Historical Museum.)

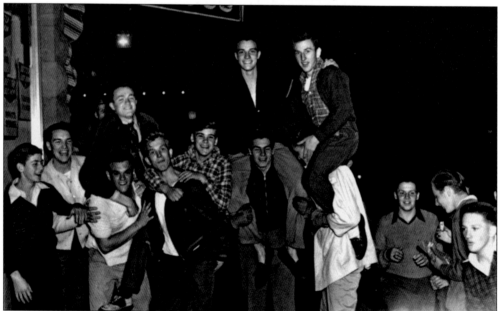

This group of exuberant teenagers is horsing around in front of Stanfield's Drugs about 1945. The four boys riding "above the crowd" on someone else's shoulder are, from left to right, Dick Stanfield, Pete Simmons, Dick Young, and Wesley Donovan. Those standing are, from left to right, unidentified, Bub Young, Don MacNaughton, two unidentified, Don Wilkerson, Roger Koops, unidentified, and George Newell. (Rockford Area Historical Museum.)

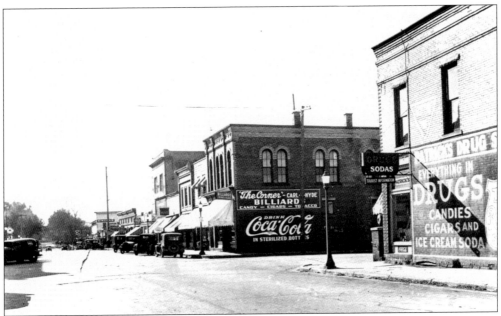

In the late 1920s or early 1930s, this Coca-Cola sign drew attention to the Corner, Carl Hyde's emporium where men could buy candy, cigars or tobacco, and of course cola in a sterilized bottle. This building, on the southwest corner of Main and Courtland Streets, was one of the few to survive the fire of 1898. Patrick's Drug Store was on the northwest corner. Inside was an old-fashioned and well-patronized soda fountain. (Rockford Area Historical Museum.)

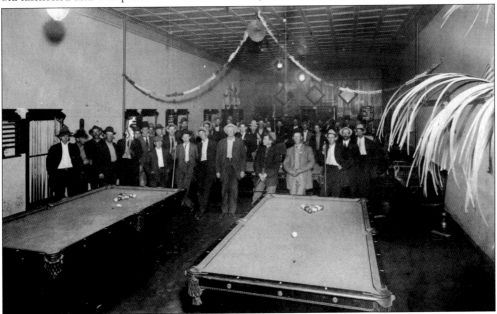

Pool halls were popular gathering places for Rockford men. For a number of years in the early 1900s, one or another of the buildings on the west side of Main Street hosted billiard and pool games. The Corner, in the photograph at the top of this page, is called the Corner Bar in the 21st century, but it was not until after 1950 that women were allowed to play pool. (Rockford Area Historical Museum.)

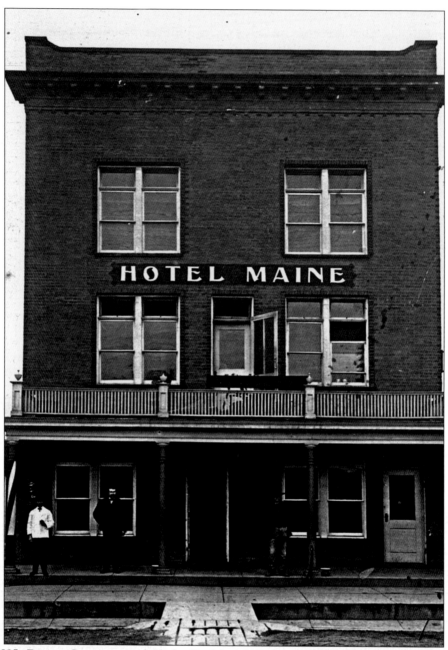

In 1895, Dennis Coon approached the Rockford Village Council with plans for building a state-of-the-art, three-story hotel on the west side of Main Street. All three floors were heated and equipped with plumbing and electricity. It opened for business in 1899 as the Hotel Maine. It was not named after the street, but rather the battleship *Maine* that sank in the Havana harbor on February 15, 1898. About 50 veterans attended the flag raising the morning of the hotel's opening on January 27, 1899. During that day, over 400 people were served dinner by the landlord. About 100 continued to celebrate by participating at a gala dance. According to the *Rockford Register*, "Those old veterans were determined to conquer the two-step or die in the attempt." (Rockford Area Historical Museum.)

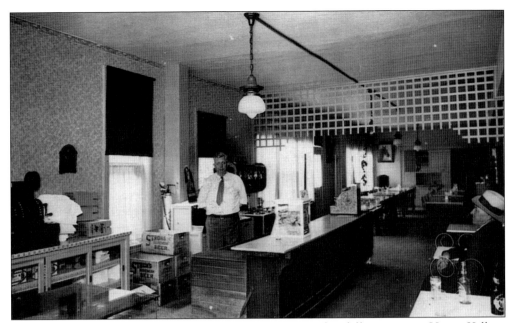

By the late 1920s, the Hotel Maine had a new owner and a different name. Henry Kellogg purchased the business in 1927 and renamed it the Rockford Hotel. Over 80 years later, it is still known by that name. In the photograph above, Kellogg is standing behind the bar while an unidentified customer sits at a table. The boxes indicate Michigan's own Stroh's Bohemian Beer was served in 1933. (Rockford Area Historical Museum.)

For 50 years, Leigh E. Sears served Rockford as a dry goods merchant. His father, Charles F. Sears, started the business in 1883. By 1889, Charles constructed a new store adjoining the Sage Block on the northwest corner of Courtland and Main Streets. Upon his father's death, Leigh E. Sears took over management of the store. In 1950, the Sears-Coon store was purchased by Melvin Baldwin. (Rockford Area Historical Museum.)

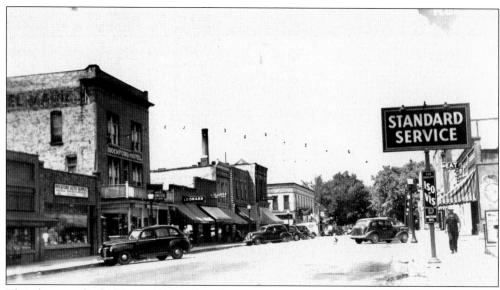

The photograph above is a 1930s view of Main Street looking north from Bridge Street. The first building on the left is the Rockford Hardware Company, and next to the hardware store is the Rockford Auto Supply. The tall building is the Rockford Hotel, previously named the Hotel Maine. Just beyond the hotel are Leonard's, Ed Bennett's, and the billiard parlor. For many years, the Standard Oil gas station occupied the opposite side of the street. That station is pictured in the photograph below. Before being demolished, it was located between the Woodshed Bar and the Bell Telephone building. Below, Henry Schumacher kneels next to his Standard Oil delivery truck with a canine friend. (Rockford Area Historical Museum.)

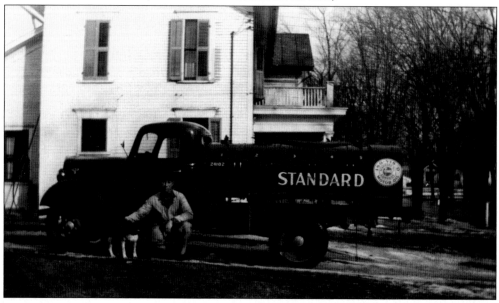

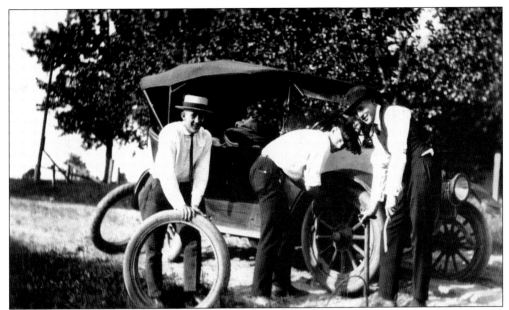

From left to right, Art Cliff, Albert Elkins, and Ardie Elkins change a damaged tire. In the 1920s and 1930s, few roads were paved. Most consisted of sand, gravel, and potholes. Automobile tires were hardly state of the art and prone to getting punctured when rolling over sharp rocks or deep holes. (Noreen Norman Elkins)

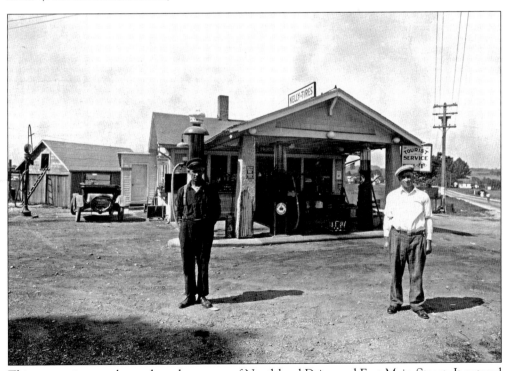

This gas station was located on the corner of Northland Drive and East Main Street. It catered to tourists and also sold Kelly tires. Leon Roosa stands on the left with Ben Roosa at his side. The picture was taken about 1926. (Rockford Area Historical Museum.)

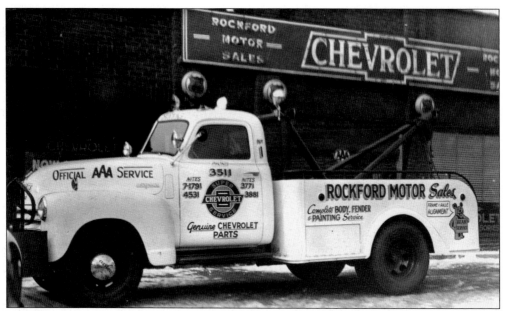

In 1948, a new wrecker was purchased by Rockford Motor Sales. The business was located on the northwest corner of Bridge and Main Streets. As well as selling new Chevrolet automobiles, it repaired cars, sold parts, did alignments, or fixed dings, dents, and scratches. If customers wanted to change the color of their cars, it could do that too. (Rockford Area Historical Museum.)

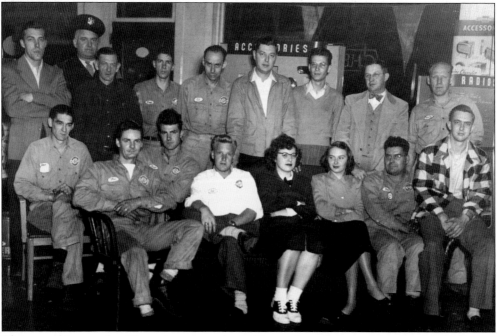

Those working at the Chevrolet garage in 1948 are, from left to right, (first row) George Hunting, Phil Downing, Frank Hall, Bob Simons, Bernice Brower, Joyce Stacey, Bud Siebold, and Bob Koster; (second row) Don Bixby, Lyle Jackson, Gale Anderson, Ernie Dell, Eldred Matthews, Walter Baker, Bob Reynolds, Lee Aldrich, and Harry Myers. (Rockford Area Historical Museum)

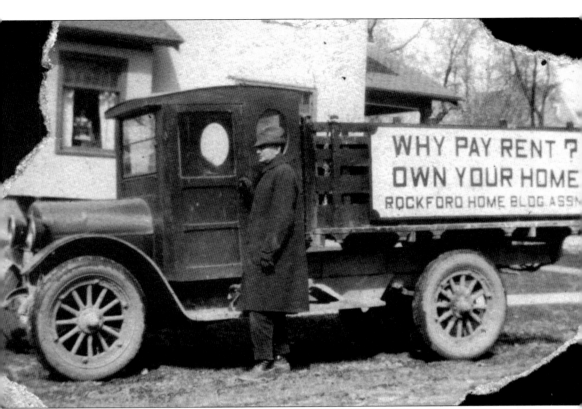

After World War I, a lack of local housing limited the number of employees that could be hired. The Hirth Krause Shoe Company in particular needed more workers. In 1919, local citizens organized the Rockford Home Building Association to remedy the situation. In 1923, the association created the town's first residential development. Three new streets in the northeast corner of the village were mapped. Elwin Giles was designated as the general contractor. He set up a production line operation with several crews of workmen following one another in various phases of construction. However, each home was still far more distinct from its neighbor than those built later in cookie-cutter developments. These homes are still referred to as the "new addition." (Vance Harger.)

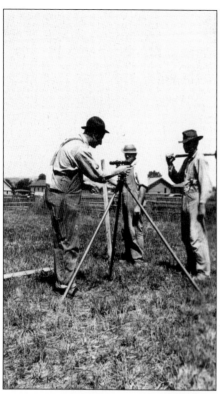

Elwin Giles checks a transom as he begins the process of determining exactly where the new Wolverine Shoe Company powerhouse will be erected. Giles had his hand in constructing a number of structures in the greater Rockford area. Glen Hutchings is observing the process, while Guy Manbeck appears ready to turn over the first shovel of earth. (Vance Harger.)

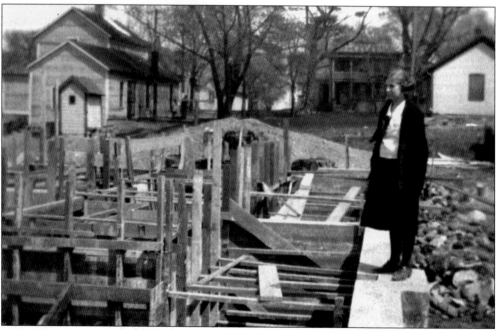

Myrna Giles observes the construction of the Wolverine Shoe Company powerhouse. It is likely that her father, Elwin Giles, is standing just outside the picture frame supervising the carpenters working on the job. The house in the background with the two-story porches is the home of the Coon family. (Vance Harger.)

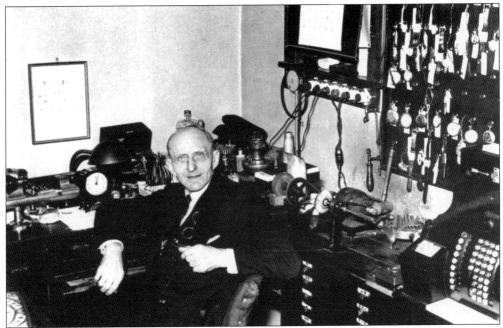

For 33 years, Peter K. Jensen served Rockford residents at his jewelry store on the north side of Courtland Street. He was a native of Germany and served in the German army under the former kaiser. In spite of a lengthy illness that led to his death in 1940, he always greeted friends with a smile. In the late 1930s, Harold R. Farrell purchased the store. (Rockford Area Historical Museum.)

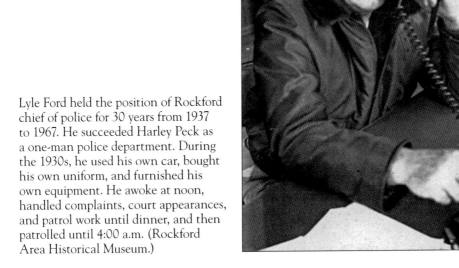

Lyle Ford held the position of Rockford chief of police for 30 years from 1937 to 1967. He succeeded Harley Peck as a one-man police department. During the 1930s, he used his own car, bought his own uniform, and furnished his own equipment. He awoke at noon, handled complaints, court appearances, and patrol work until dinner, and then patrolled until 4:00 a.m. (Rockford Area Historical Museum.)

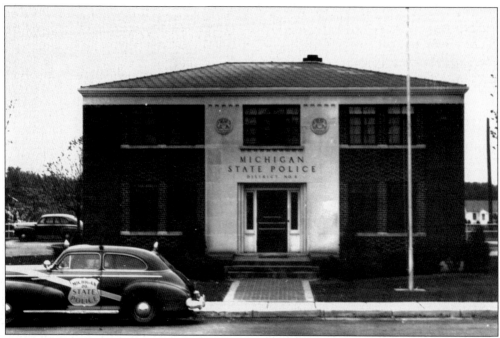

The Rockford Michigan State Police post was first established on February 15, 1932. The original contingent consisted of Cpl. Stanley Peoviak and troopers Ray Loomis, George Milligan, James Boden, and Quentin Dean. The permanent building above was completed in 1937. At its opening on January 9 and 10, over 1,200 people toured the new facility. (Rockford Area Historical Museum.)

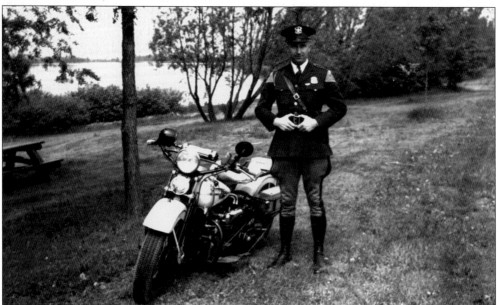

The state policeman standing beside his Harley-Davidson motorcycle is Don Downer, son of Lyle and Maisie Downer. A local boy, he grew up on Maple Street and graduated from Rockford High School. This photograph was taken in the late 1930s or early 1940s. (Rockford Area Historical Museum.)

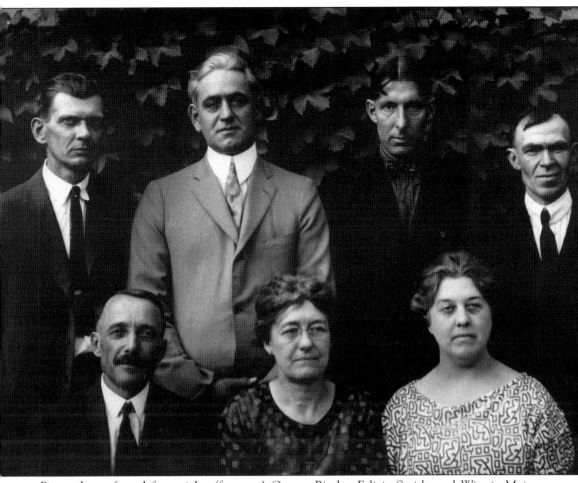

Pictured are, from left to right, (first row) George Binder, Felicia Smith, and Winnie Muir; (second row) Otto Krause, Jess Muir, George Platt, and John Rinkevich. Otto's father, G. A. Krause, and his uncle Frederick Hirth were the moving spirits behind the Hirth Krause Shoe Company, located first in Grand Rapids. They opened a new facility in Rockford in 1903. The business continued to expand, and in 1921, it was renamed the Wolverine Shoe and Tanning Corporation. Members of the Krause family remained involved with the business for many years. Jess Muir was the first superintendent of the shoe factory. (Rockford Area Historical Museum.)

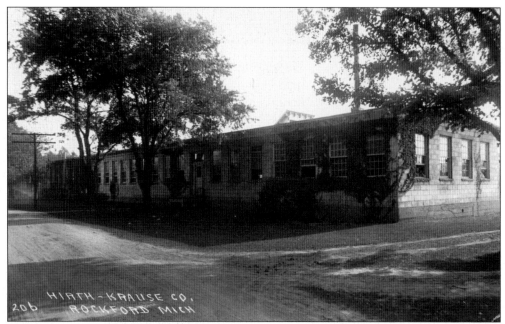

This small building, 45 feet wide and 2,000 feet long, was the first Hirth Krause Shoe Company manufacturing facility. It was built on vacant land next to the railroad tracks on North Main Street. Muriel Wolven Harrington was the company's first production employee, starting in the cutting room on May 25, 1903. In 1906, production had increased enough that an addition was warranted. (Rockford Area Historical Museum.)

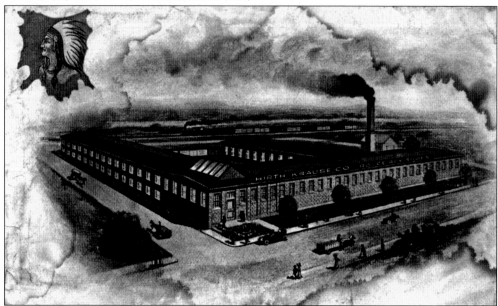

The graphics on this envelope show the Hirth Krause factory. In addition to manufacturing footwear using labels designated by its customers, Hirth Krause marketed its own line under the name Rouge Rex Shoes. These shoes used a trademark showing a Native American in a feathered war bonnet superimposed on tanned cowhide. The Rouge Rex name was widely known and highly regarded. (Rockford Area Historical Museum.)

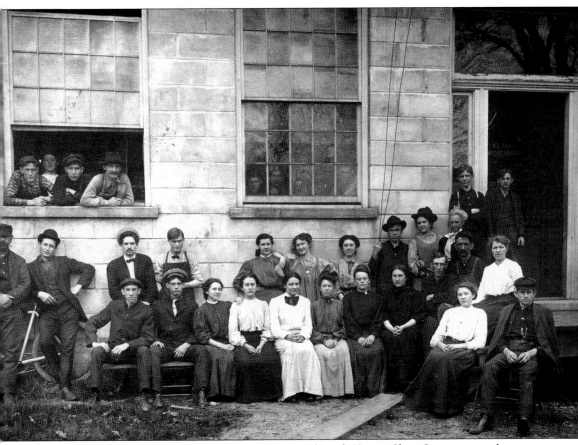

This 1905 photograph is the earliest known picture of Hirth Krause Shoe Company employees. Full production had only begun in 1903. The glass in the door states, "We pay Wednesdays." From left to right are (first row, seated in front of the steps on the far right) Gladys Elkins (Mrs. Roy) Denton and Carl Miller; (second row) Wallace Inman, George McIver, Ada Wilkinson Teesdale, Amber Elkins Peterson, Ann Kies Church, Lottie Gormell Saunders, Nellie Loomis Kellogg, Muriel Wolven Harrington, unidentified, John Hessenius Sr., and unidentified; (third row) Orlan Allen, Frank Clark, unidentified, Roy Denton, Minnie Eldred Armstrong, Hazel Lovelace Rector, Winnie Wilkinson Muir, John Rinkeviczie, Grace Wilkinson Hall, Blanche Husted, unidentified, and Rollo Bellows. The four people leaning out the open window are, from left to right, Iden Eadie, unidentified, George Platt, and Albert Berry. (Rockford Area Historical Museum.)

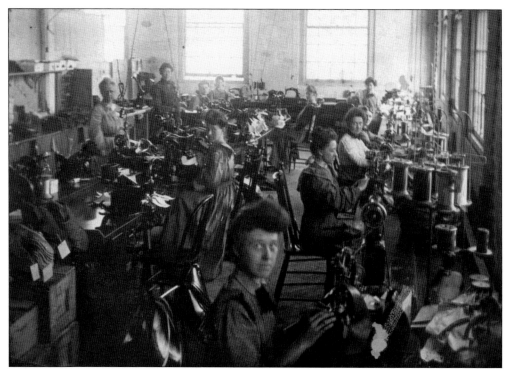

Women were accepted as an integral part of the workforce at the Hirth Krause Shoe Company almost from its inception. Sewing machines with numerous spools of thread were used in piecing together tough leather boots. Later those wooden spools would become legendary collectables for local residents. (Rockford Area Historical Museum.)

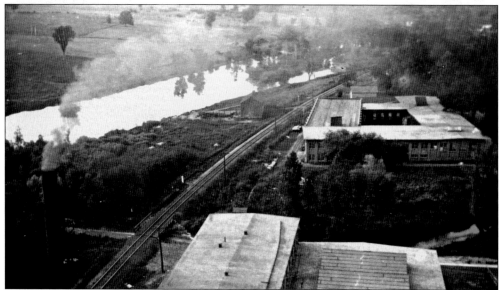

In 1922, an ambitious photographer climbed up the scaffolding surrounding the construction of the new smokestack to take pictures from a higher point of view. The square building above is the shoe factory. The small waterway on the left side of the image is Rum Creek. Looking north, both the Rogue River and the smoke fade into the distance. (Rockford Area Historical Museum.)

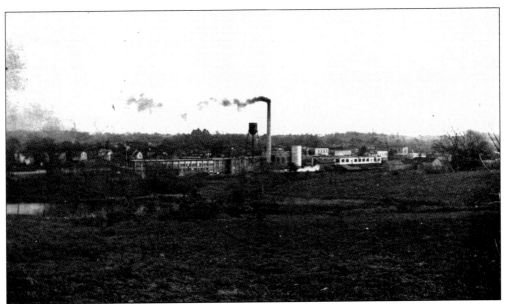

This postcard states, "Distant view of Rockford Leather Factory in Rockford, Michigan." In 1922, the Hirth Krause Shoe Company built a new steam power plant south of the tannery. Its 150-foot-high concrete smokestack was the tallest structure and became Rockford's principal landmark at that time. (Rockford Area Historical Museum.)

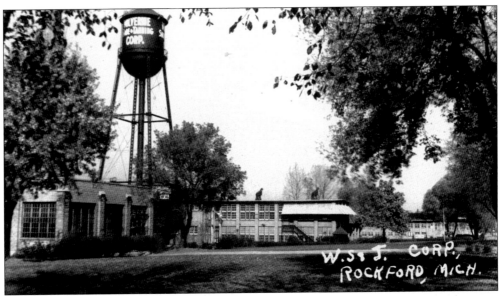

The Wolverine Shoe and Tanning Corporation became one of the most innovative manufacturing facilities in the United States. At first only the tannery bore the Wolverine name, while Hirth Krause became the Michigan Shoemakers. In 1921, the company unified, becoming the Wolverine Shoe and Tanning Corporation. That same year, the business expanded, making gloves as well as footwear. (Terry Konkle.)

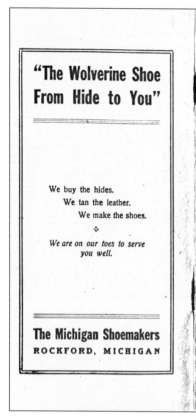

A multipage booklet published late in the second decade of the 20th century and the 1920s was touted as the *Michigan Shoemaker*. As well as advertising various types of footwear, it included short moral stories, jokes, and philosophical comments. A typical example is "Of course the leopard cannot change his spots; what does he know about politics?" In 1924, the title was changed to *Wolverine News*. The new publication focused more on the workers lives and local news. (Terry Konkle.)

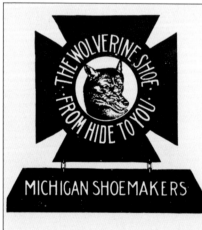

Penny postcards were an excellent marketing tool before the advent of television and computers. The Wolverine Shoe Tannery used the logo above with its grinning wolverine. The card also emphasized the fact that the company "did it all," from preparing and tanning the leather to stitching the shoe. (Jack Bolt.)

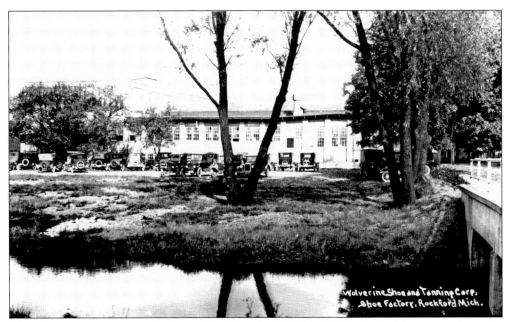

This photograph was taken in the 1920s when the Ford Model T and the fabric-topped touring car were still commonplace. This view is of the Wolverine Shoe Tannery from the opposite bank of Rum Creek. Many willows lined the banks of the creek. Main Street goes over the bridge. (Rockford Area Historical Museum.)

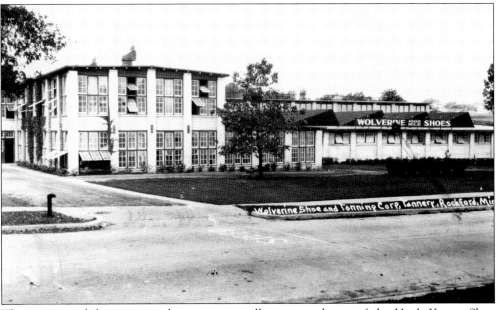

The tannery, while a separate business, was still an integral part of the Hirth Krause Shoe Company. When the two became the Wolverine Shoe and Tanning Corporation, leather production increased. The sign on the building touts the durability of the company's products, proclaiming that they are "1,000 Mile Shoes." (Rockford Area Historical Museum.)

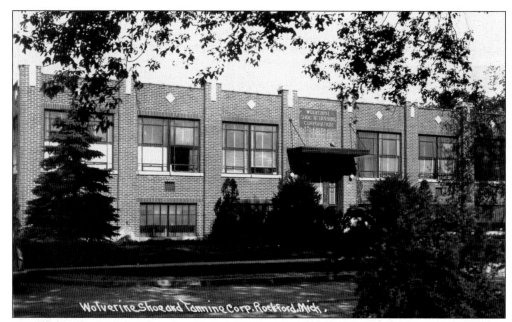

The Wolverine Shoe and Tanning Corporation continued to expand, constructing several new, and now familiar, facilities to house additional employees. The photograph above shows the administration building after it was completed. It used an innovative conveyor system to move mail and paperwork from one office to another. (Rockford Area Historical Museum.)

During the tough years of the 1930s, G. A., Otto, and Victor Krause did everything in their power to see that employees were not laid off. The Wolverine Shoe and Tanning Corporation was one of the first to offer profit sharing to its workers. Happy and contented employees were a major reason the company continued to expand its market share. (Rockford Area Historical Museum.)

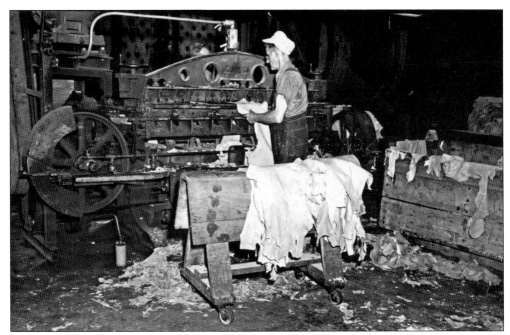

Like many shoe-making companies, Hirth Krause first used cowhide. Wishing to make a more durable shoe, the company invented its Shell Horsehide triple-tanning process. Well-prepared horsehide made for a much longer wearing boot. In the image above, Fred Wood works on the splitting machine. (Rockford Area Historical Museum.)

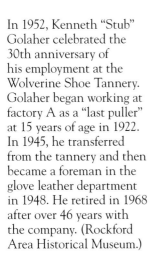

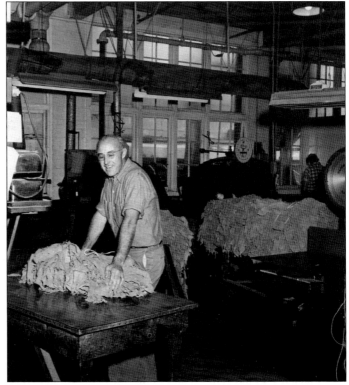

In 1952, Kenneth "Stub" Golaher celebrated the 30th anniversary of his employment at the Wolverine Shoe Tannery. Golaher began working at factory A as a "last puller" at 15 years of age in 1922. In 1945, he transferred from the tannery and then became a foreman in the glove leather department in 1948. He retired in 1968 after over 46 years with the company. (Rockford Area Historical Museum.)

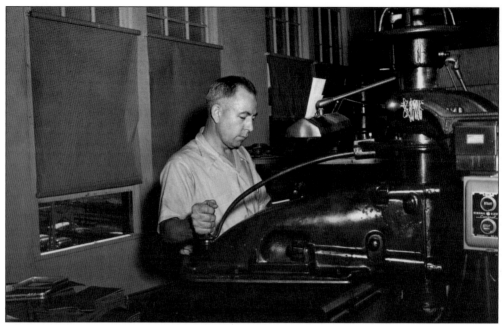

Once the hides are prepared, the pieces of leather must be cut to match specific shoe patterns. In the photograph above, Wilfred (Bill) Paull works on a machine that cuts out leather uppers. He wears a protective apron while using the machinery. Scraps are pushed off the table to fall at his feet. This picture was taken in 1939. (Leigh Paull.)

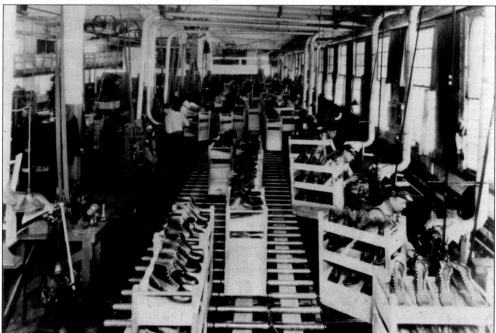

The Wolverine Shoe Corporation made ample use of Henry Ford's innovative assembly line whenever possible. However, shoe making still required skilled workers to create a quality product. Above, a series of rollers conveys shoes from one area of the factory to another. (Rockford Area Historical Museum.)

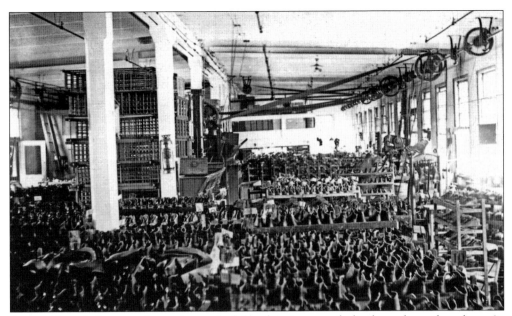

A sea of work boots waits to be packed for shipping to wholesale and retail outlets. As production increased, warehouse space was sometimes at a premium. The Wolverine Shoe Company managed a fleet of trucks to assist in the distribution of its products. (Rockford Area Historical Museum.)

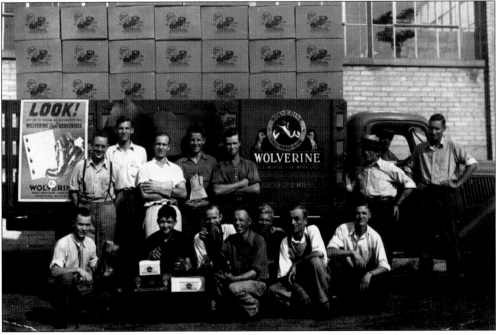

These men are part of the Wolverine warehouse group around 1939–1940. From left to right are (first row) Red Carland, Bernard Johnson, Bob Strom, Bill Elfstrom, ? Haskins, Clyde Ashley, and Kyle Sinclair; (second row) Bud Hardie, Quint Elkins, Rob Wolven, Bob Tuttle, and Glenn Johnson. Their boss, Bill Browning, leans on the truck by the cab. Roy Donavan is inside the truck, and Earl Smith stands by the hood. (Rockford Area Historical Museum.)

The Wolverine Shoe Company regularly recognized and rewarded its employees. In the photograph above, George Platt is presented with an award. From the left are ? Bowers, Ellis Crandell, Richard Arver, Victor Krause, Iden Eadie, and George Platt. The picture was taken during the late 1940s. (Rockford Area Historical Museum.)

Wolverine Shoe Company executives and workers often lunched or attended meetings at Russell's Café. It was located at the corner of Northland Drive and East Main Street. Those seated at the table are, from left to right, unidentified, Gordon Krause, ? Nolton, Dayton Fisher, two unidentified men, Adolph Krause, Otto Krause, John Jansen, Dick Krause, two unidentified men, Neil Forrest, and E. J. Bennett. (Rockford Area Historical Museum.)

Three

SCHOOLS AND CHURCHES

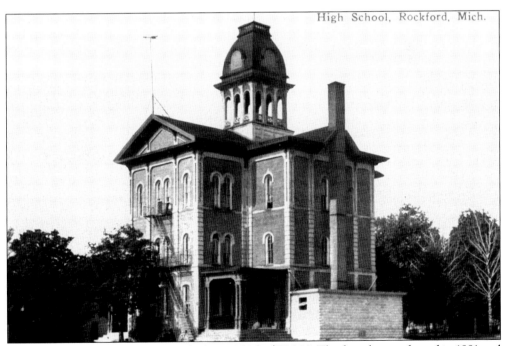

High School, Rockford, Mich.

The three-story Union School was built in 1871 for $71,000. The first class graduated in 1881 and consisted of three students. It was thought that the school was so large that Rockford students would never use all of its rooms, but by 1921, the graduating class put desks on the platform in the assembly room, and several lower grades were quartered in a downtown poolroom. (Terry Konkle.)

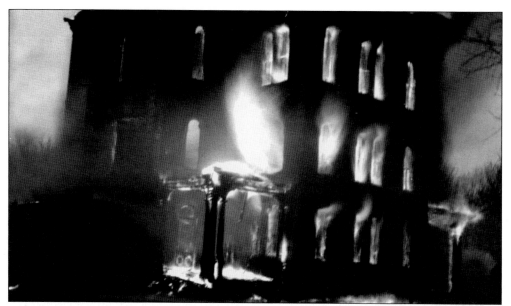

After having caught fire several times previously, the school was finally destroyed on February 3, 1922, at 4:00 a.m. Most records and all the silver trophy cups were lost. Local residents took literally scores of pictures of the burning school. Many postcards recording the event are still in circulation. (Rockford Area Historical Museum.)

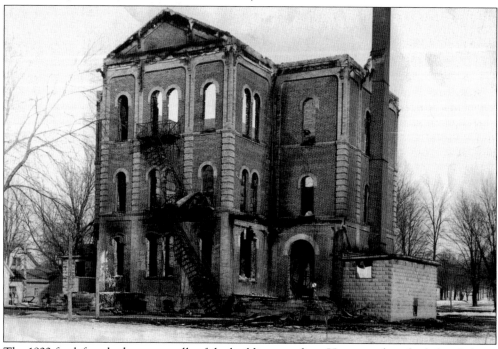

The 1922 fire left only the outer walls of the building standing. However, there had already been discussion regarding a larger and more modern school. The first time the school board voted on the need for a new building there was a tie. The second time the issue lost, but a planning committee was appointed. After the fire, the board voted a third time and approval was granted. (Rockford Area Historical Museum.)

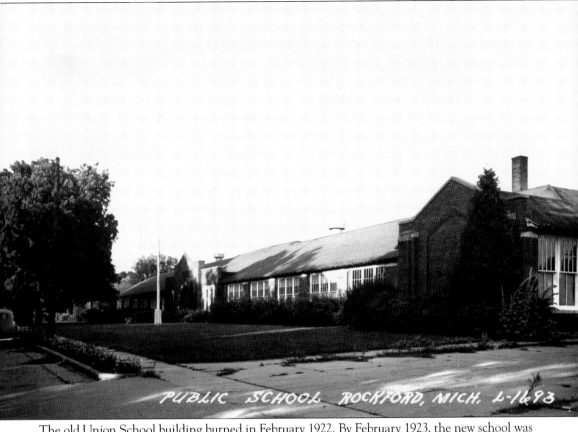

PUBLIC SCHOOL ROCKFORD, MICH. L-1693

The old Union School building burned in February 1922. By February 1923, the new school was occupied and running smoothly. This building for kindergarten through 12th grade was the first school in Michigan to have all its classrooms on one level. A unique coincidence was uncovered when it was discovered that the architect of the new building was the son of the man who drew up the plans for the old Union School built in 1871. The new building cost $108,000 with an additional $12,000 for equipment. Some of the bricks used in its construction were taken from the remnants of the burned-out hulk of its predecessor. (Rockford Area Historical Museum.)

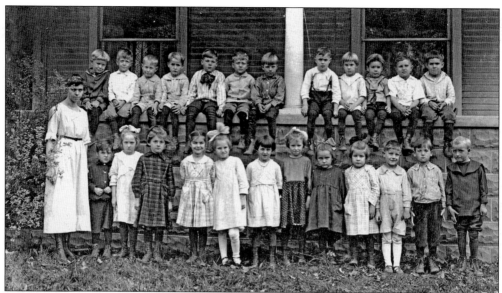

The teacher, Miss Forest, stands on the left. The students are, from left to right, (first row) Clayton Russel, Dorothy Pressy, Naomi Russel, Dorothy Laughlin, Clair Souffrou, Vivian Lovelace, Dorothy Dean, Maxine Streeter, Evelyn Squires, Donald Burch, Richard Fowle, and Kenneth Colby; (second row) Gerald McNitt, Georgie Fritch, Gaylord Sowerby, Dick Hunting, Norman Wood, Glenn Streeter, Donald Reid, Otto Bellows, Wayne Bellows, Val D. Brown, Max Bird, and Howard Rinkeviczie. (Rockford Area Historical Museum.)

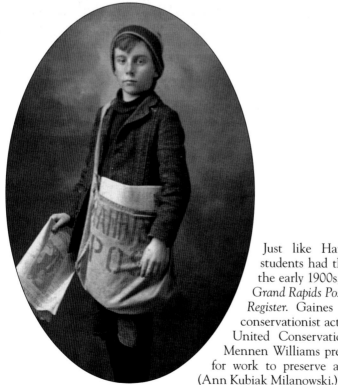

Just like Harry Gaines, many Rockford students had their own newspaper routes. In the early 1900s, Gaines delivered for the daily *Grand Rapids Post*, instead of Rockford's weekly *Register*. Gaines went on to be a dedicated conservationist actively supporting the Michigan United Conservation Club. In 1955, Gov. G. Mennen Williams presented Gaines with an award for work to preserve and protect the environment. (Ann Kubiak Milanowski.)

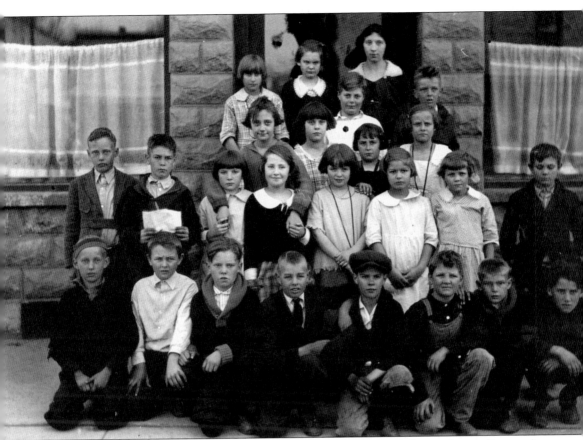

The students above attended Rockford schools in the 1920s. From left to right are (first row) Lyle Wood, Jewell Squires, Leigh Johnson, Rollo Grant, Howard Albers, Theodore Marset, Dan Plat, and Lee Graves; (second row) Lynn Hardie, George Hunting, Nola Hutchings, Sarah Finch, Doris Kimon, Marion Betts, Lene Pearl Springs, and Fred Winegar; (third row) Bernice Bishop, Margret Matherson, Laura Jessup, and Lorna Rose; (fourth row) Hugh H. Long and Merl Scrantner; (fifth row) Irene De Vries, Mildred Loveless, and teacher Celara Mitchell. (Rockford Area Historical Museum.)

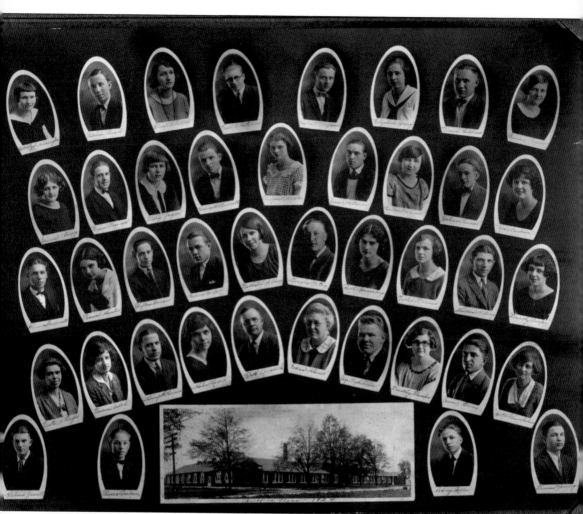

The second class to graduate from the new high school was the class of 1924. From left to right are (first row) Ethelyn Pennington, Wilford Finch, Clara Scholpp, Earl E. Hutchins, Leslie Kingman, Elizabeth Spring, Thomas Parkhurst, and Francis Taylor; (second row) Gracia Strong, Myron Turner, Mary Jaqua, Edward Bennett, Margaret Hessler, Jesse Peterson, Laura Graves, Julius Turner, and Eva Benham; (third row) Glenn Woodworth, Frances Hunter, Clifton Wonders, Elwin Cooper, Nathalie Bellows, Douglas Oatley, Ruth Spanenberg, Violet Dennis, Holden Spring, and Dorothy Cooper; (fourth row) Vesta Sturges, Norma Welch, Henry H. Lemoin, Helen Lamb, E. H. Chasselle, Edna Haner, Jay Dykehouse, Dorothy Manshaw, Jason Stevens, and Ruth Chamberlain; (fifth row) Richard Jewell, Theodore Carlson, Rodney Weller, and Thomas Young. (Rockford Area Historical Museum.)

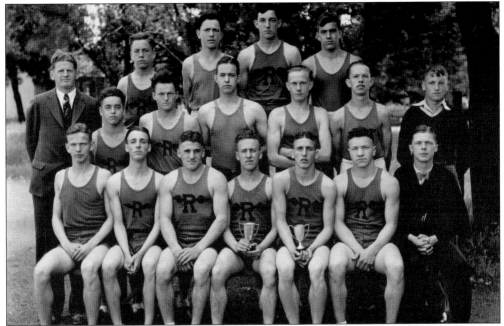

The 1930 Rockford High School track team won several silver cups. The team consisted of, from left to right, (first row) Dudley Bowers, William Presser, Lee Graves, Ferris Coon, Carl Streeter, Rex Ten Eyck, and Arden Young; (second row) coach Lyle Bennett, Ed Fisher, Ken Norman, Harry Kellogg, Clarence Blakeslee, Gerald Gordon, and Richard Fowle; (third row) Russell Heinz, Basil Blakeslee, Russ Inwood, and Merle DenBraber. (Terry Konkle.)

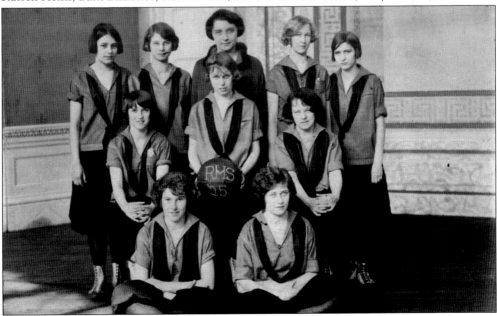

Members of the 1924–1925 girls' basketball team are, from left to right, (first row) Theo Pratt Stauffer and Josephine VanVyven Hodgson; (second row) Elizabeth Krause Sherwood, Mary Skrine Stacey, and Norine Turner Ronan; (third row) Charlotte VanVyven Brose, Mary Kolkema Thomas, coach Helen Meyer, Doris Johnson Squires, and Virginia Hunting Jones. (Terry Konkle.)

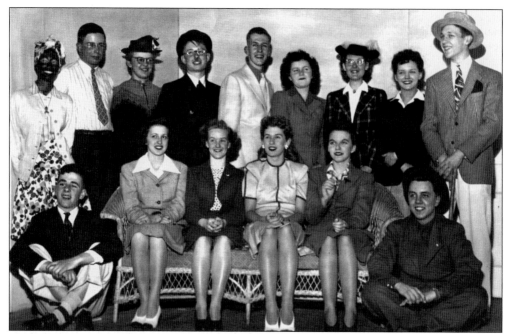

In the mid-1940s, local high school thespians produced a play. The cast includes, from left to right, (first row) Paul Blakeslee, Pat Benham, Sis Simmons, Jill Krause, Janice Rust, and Terry Smith; (second row) Maxine Weller, Art Finch, Alma Schwab, Gene Burch, unidentified Nola Smith, possibly Dorothy Helmer, Nancy Hessler, and Armie Caswell. (Rockford Area Historical Museum.)

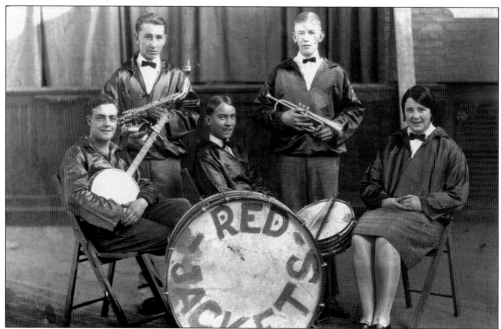

The Red Jackets were the Rockford High School dance orchestra in 1927. Bob Childs was the saxophonist, Ken Squires was the trumpeter, Jack Fetter played the banjo, and Lyle Reynolds was the drummer. Dorothy Wilkinson played the piano. (Rockford Area Historical Museum.)

From left to right, Sheldon Wilkinson, Harlow Blumenstein, and Richard Jewell pose on the athletic field in back of the old high school on North Main Street. Blumenstein proudly holds a 1924 baseball trophy showing that Rockford High School defeated Grandville High School 7-6. (Rockford Area Historical Museum.)

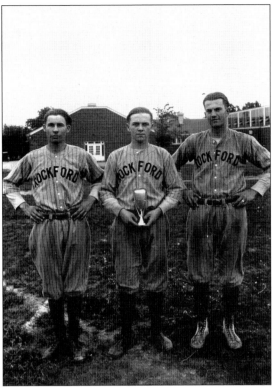

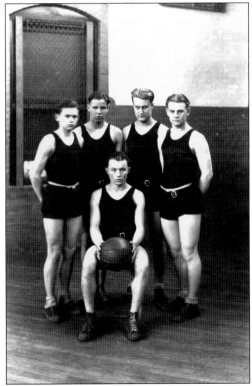

Shoes worn by basketball players in the 1920s lacked the high style of more recent footwear. The 1927–1928 Rockford basketball team is featured in the photograph at left. The four boys standing are, from left to right, Gordon Krause, Burdett Stacey, Melvin Letts, and Elwood Blumenstein. Loren Stauffer is seated holding the ball. (Terry Konkle.)

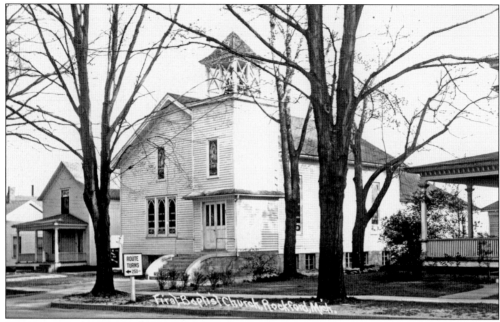

The Baptists completed building their church in 1859. Organized in 1854 as First Regular Baptist, such historic family names as Hutchins, Watkins Gilvert, Long Briggs, Stilwell, and Allen were written on early membership rolls. After several additions were erected, the old church was torn down and a newer, more modern building constructed. (Terry Konkle.)

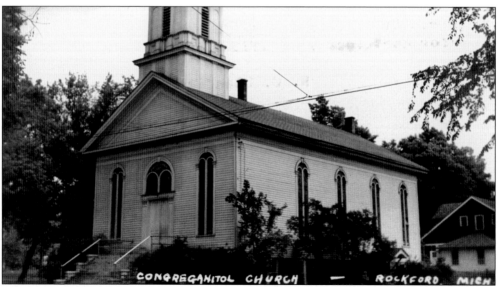

From the late 1840s until 1875 when the church building was completed, the Congregationalists met in homes, meeting rooms, or schools. That building is now the sanctuary of the present church and still stands at its original site on the southwest corner of Bridge and Fremont Streets. (Rockford Area Historical Museum.)

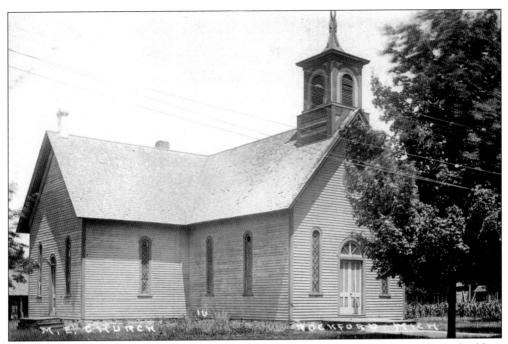

In 1853, Laphamville's Methodist Episcopal Church was organized. In 1865, a two-story building was purchased from Samuel Squires and moved to the present church site on Maple Street and remodeled. It was topped by a small graceful steeple and bell tower. This was the first church bell to ring in Rockford. The photograph above shows how the church appeared before 1877 when the original rectangular church received an addition. (Terry Konkle.)

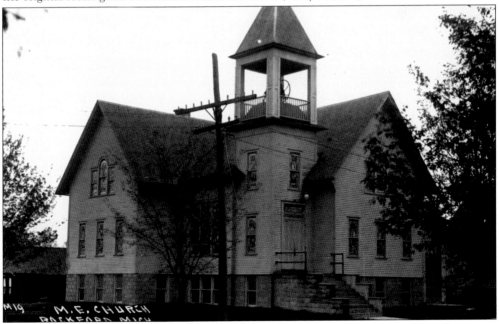

Above, the Methodist Church was remodeled and modernized in 1907 with a basement, balconies, stained-glass windows, a new corner main entrance, and a belfry. An educational building was added in 1957 and an updated entrance in 1962. (Terry Konkle.)

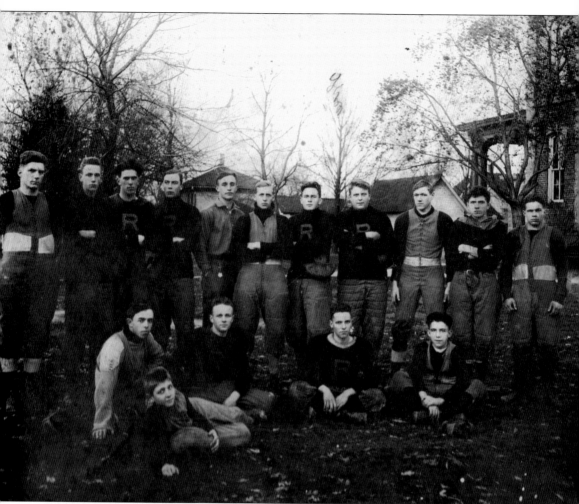

The boys in this picture formed Rockford's first football team. It was 1913, and the team had two footballs: one for practice scrimmages and the other reserved for games. To compete, they had to travel to Grand Rapids, Sparta, Allegan, Ionia, Charlotte, and Plainwell. It was a successful initial season, as the team won 9 out of 10 games. From left to right are (first row) Vernon De Puy, Dick Krause (mascot), Rex Baker, Charles Sears, and Bob Binder; (second row) Clifford Carlyle, Bob Rewick, Lloyd "Spooks" Scoville, Cecil Porter, coach Cyrus Kuyers, Elliott John Oatley, James Gaylord Muir, Melborne Hutchings, Harold Kitson, Harvey Docum, and Glenn Thompson. (Rockford Area Historical Museum.)

Four

ORGANIZATIONS
AND GROUPS

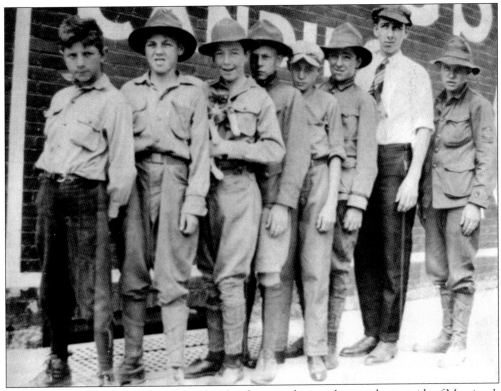

This is the 1915 Boy Scout "Crow Patrol." The photograph was taken on the east side of Morrison's Drug Store (later Patrick's) by scoutmaster Benjamin Squires. From left to right are Holden Spring, Neil Forrest, Robert Newcombe, L. E. Van Antwerp, Rolland Jessup, Charles Benham, George Benham, and Lewis Clark, the patrol leader. (Rockford Area Historical Museum.)

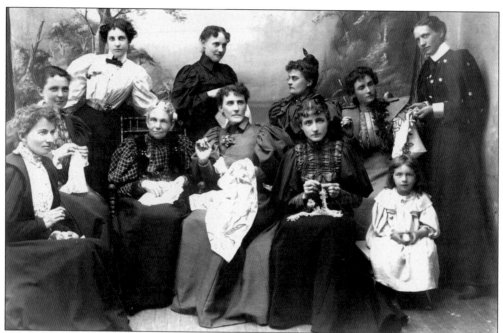

In 1885, a literary society known as the Hyptia Club was organized. Later it was known as the Tuesday Club. From left to right are (first row) Edith (Mrs. Bryant) Dockeray, Mrs. Frank Aldrich, Sarah (Mrs. William) Powell, Carie Wilson, Ida Finley, and Pauline Hessler Johnson; (second row) an unidentified visitor, Julia Shafer, Edna Dockeray, Frankie Childs, and Emma Hessler. (Rockford Area Historical Museum.)

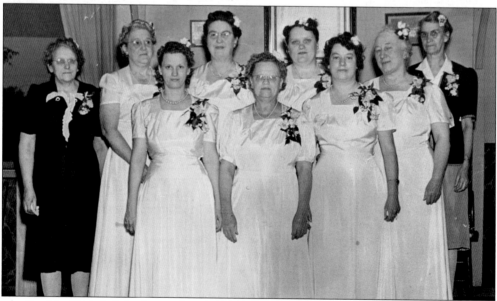

The Rockford Rebekah Lodge conferred degrees on its members. The women above constituted the degree staff. They are, from right to left, (first row) Helen Pyne, Ina Jewell, and Florence Roosa; (second row) Gladys Streeter (captain), Louella Letts, Orphe Waddell, Maxine Marcott, Muriel Harrington, and Orphe Mc Grady (musician). The photograph was taken around 1945. (Rockford Area Historical Museum.)

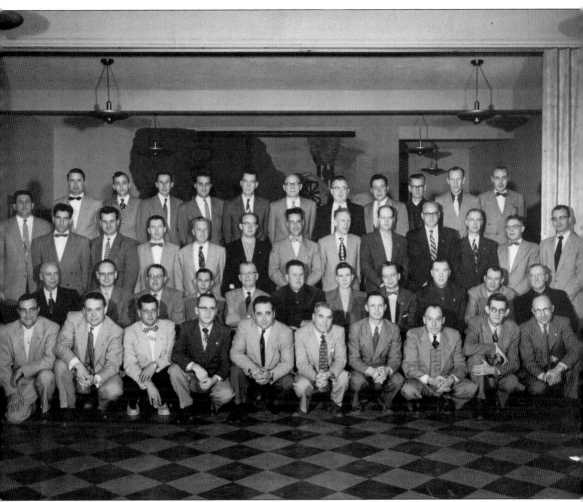

The Rockford Lions Club was chartered on April 29, 1954. Seen here are, from left to right, (first row) Jack Felter, Bob Burch, A. O. Richardson, Ernie Carpenter, Ed Fisher, Ed Leonard (president), Gerald Fox, Leo Eby, Pat Delehanty, and unidentified; (second row) Cecil Porter, unidentified, Chuck Gogo, Ernie Swinehart, Victor Krause, Rex Petersen, Jim Thomson, Loren Disbrow, Clark Carlson, John Judson, and unidentified; (third row) Jack Hart, Herman Root, David Livingston, Carl Hornbrook, Bob Simmons, Ed O'Brien, unidentified, Vic Stenenga, Fred Boyd, unidentified, Gordon Tucker, Howard Moorehouse, and Ralph Appell; (fourth row) Lynn Gill, John VanProoyen, Dr. Robert Byram, Don McMullen, Richard Solomon, Arnold Paepke, Harold Farrell, Bob Lathrop, Cecil Brooks, Gordon Hanthorn, and Neil Forrest. (Rockford Area Historical Museum.)

For many years, Rockford had an active community choir. Standing are, from left to right, Marie Ploef, Wayne Martin, Bill Paull, Loren Disbrow (director), and Jim Clark. Genevieve Buckingham, the accompanist, is at the piano. (Rockford Area Historical Museum.)

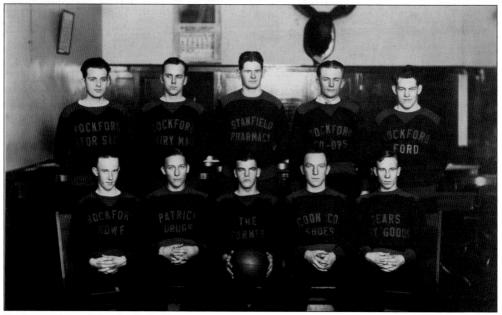

Each member of this basketball team was sponsored by a local business. They won the Kent County Y Championship. From left to right are (first row) Howard Wolven, Les Paepke, Ken Morrison, Arnold Paepke, and Harold Wolven; (second row) Ed Bennett, Harlow Blumenstein, Lyle Bennett, Roy Whittall, and Don Randall. (Terry Konkle.)

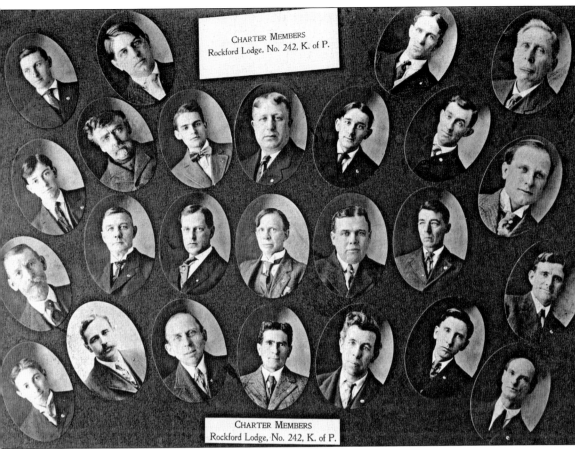

CHARTER MEMBERS
Rockford Lodge, No. 242, K. of P.

CHARTER MEMBERS
Rockford Lodge, No. 242, K. of P.

These men are the charter members of the Knights of Pythias. They are, from left to right, (first row) Ed Smith, George Meyers, Charly Eadie, and Charlie Dockeray; (second row) Will Hyde, ? Smith, Wilbur Browning, H. E. Carle, Clarence Slocum, Fred Squires, and Winfield Scott; (third row) ? Smith, Card Johnson, Art McAuley, Dr. Charles B. Newcombe, Bert Hawthaway, John Hammer, and Lloyd Becker; (fourth row) ? Smith, George Dockeray, Peter Jensen, Lou Schoffer, Will Brantner, Ralph June, and Floyd Moore. (Rockford Area Historical Museum.)

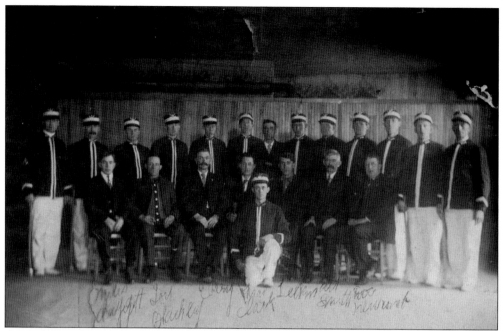

Around 1910, Rogue River Camp No. 6022 of the Modern Woodmen of America sponsored its own drill team. John Elkins is kneeling in front. Behind him are, from left to right, (seated) unidentified, Lew Blachley, Earl Perry, Frank Clark, unidentified, Arthur Smith, and Dr. C. B. Newcomb; (standing) Roy Denton, Charles Cloud, Alger Streeter, unidentified, Faye Dockeray, unidentified, Lewis Hunting, Charles Keech, Clinton Williams, Everett Betts, William Eadie, Tom Daggett, and unidentified. (Rockford Area Historical Museum.)

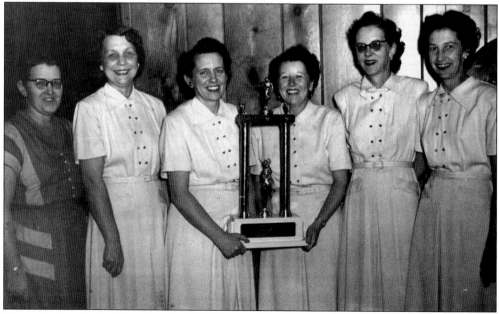

Pictured above is the champion Rockford women's bowling team of 1952. From left to right are Fran Wolven, Marguerite Robbie, Thea Smith, Doris Civils, Vivian Peterson, and Marge Price. (Rockford Area Historical Museum.)

Five

WAR AND THE
HOME FRONT

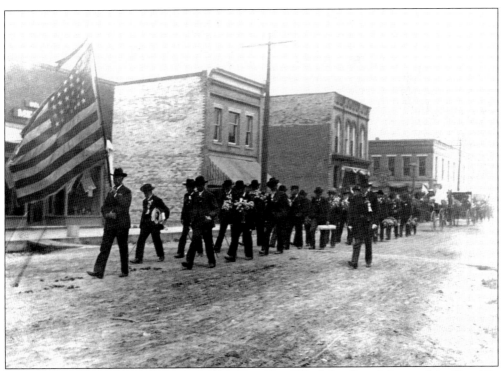

About 1990, the Rockford Peter A. Webber Post No. 237 of the Grand Army of the Republic (GAR) marches in a Decoration Day parade. Members participating include Tom Fenton, Albert Pickett, Charles Jaqua, A. Toms, Harrison Wilcox, James Eadie, Charles Haner, Captain Perry, James Stewart, Maj. E. C. Watkins, William Chapman, M. Sockelby, Will Reynolds, Frank Crammer, C. F. Sears, George Fenton, Frank Danforth, Gurd Chapel, Fred Hovey, Judson M. Spore, C. N. Hyde, and John Merrithew. (Rockford Area Historical Museum.)

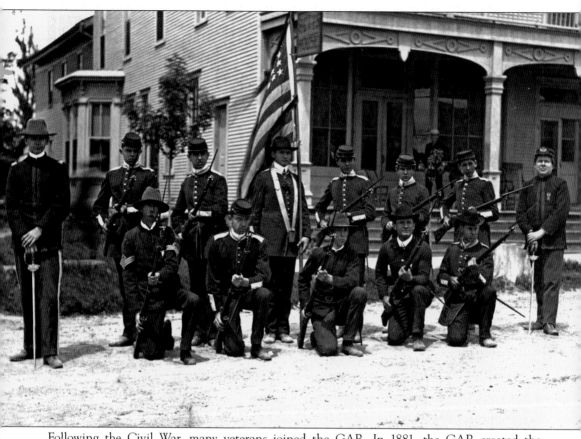

Following the Civil War, many veterans joined the GAR. In 1881, the GAR created the Sons of Union Veterans. Four years later, in 1885, Rockford Post No. 16 of the Sons of Union Veterans was organized. By 1907, the organization had disbanded to be replaced by the Rockford Independent Guards armed with more modern magazine-type Reminington rifles. The men above are members of the Sons of Union Veterans, and the photograph was taken about 1900. Only four are identified, and all are standing in the second row. Second from left is Roy Norton, third is George Myers, fourth is Everett Betts, and the man on the far right is Earl Cowdin. They are posed in front of the Betts Hotel. (Rockford Area Historical Museum.)

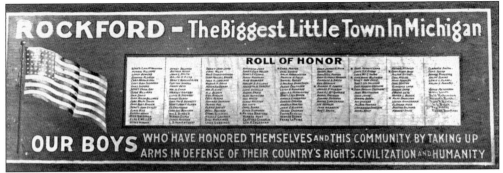

This sign honors those who served in World War I. A total of 154 men from the greater Rockford area served their country. Eight of the names on this roll of honor are denoted with a gold star indicating the men died during the war. This sign was painted on the west wall of the Sears building. (Rockford Area Historical Museum.)

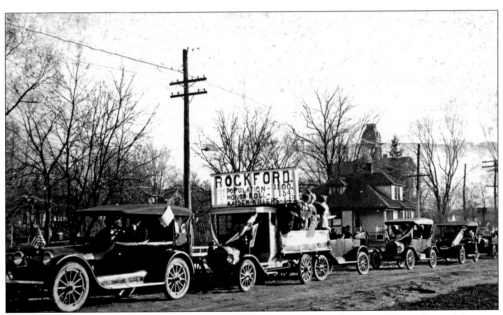

Rockford greeted the announcement of the armistice on November 11, 1918, with a celebration that included this spontaneous parade that eventually continued by motorcade to Grand Rapids. The sign reads, "Rockford. Population - 1100. Honor Roll - 154. Kaiser-Killers - 14. The tall building in the background is the Union School built in 1871. (Rockford Area Historical Museum.)

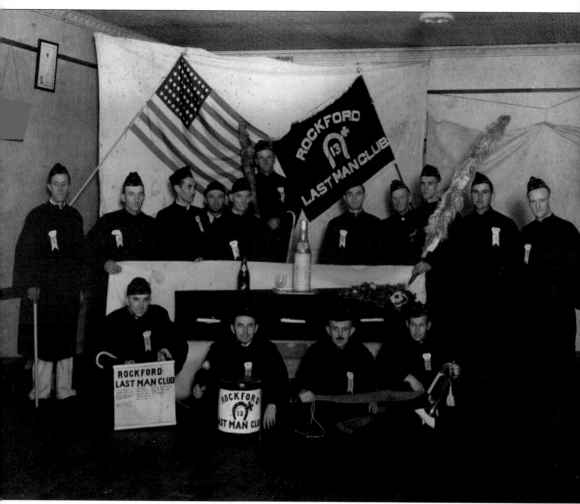

For many years, on every Friday the 13th, the Last Man Club gathered for a banquet. At the head table was a sacred bottle of champagne obtained from a wine cellar near Argonne, France. Club members were all World War I Rockford area veterans. They made a pact that the last living member would drink a toast to his comrades. That "last man" was Herb Crothers, who did not drink and did not have the heart to open it. Crothers passed away in 1979. Standing in back in the middle holding a club is Charles Shier. Seated on the floor are, from left to right, Crothers, George T. Bennett, Louis Salzman, and Lee Cook. Standing behind are, from left to right, Mel Eadie, William Carr, F. B. Squires, Otto Spanenberg, Dr. Julius F. Peppler, Cliff Millard, possibly Louis Ruge, Iden Eadie, Wayne Zimmerman, and Herman Mc Lean. (Rockford Area Historical Museum.)

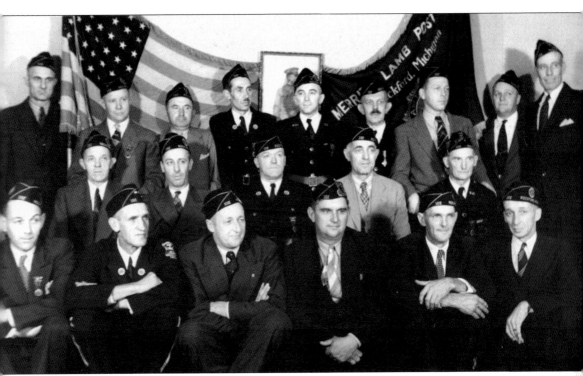

This photograph of the Merritt Lamb American Legion Post was taken in the late 1930s or early 1940s. From left to right are (first row) Rex Humphrey, Iden Eadie, Hollis Baker, Wayne Zimmerman, unidentified, and Earnest Blanchard; (second row) George Streeter, unidentified, Willis C. Young, Charles Harris, and Dr. Julius F. Peppler; (third row) Frank Winters, Clarence Lamb, George Bennett, Ben Squires, Herbert Crothers, Louis Salzman, Clyde Casewell, Rex Baker, and Walter Robbie. (Rockford Area Historical Museum.)

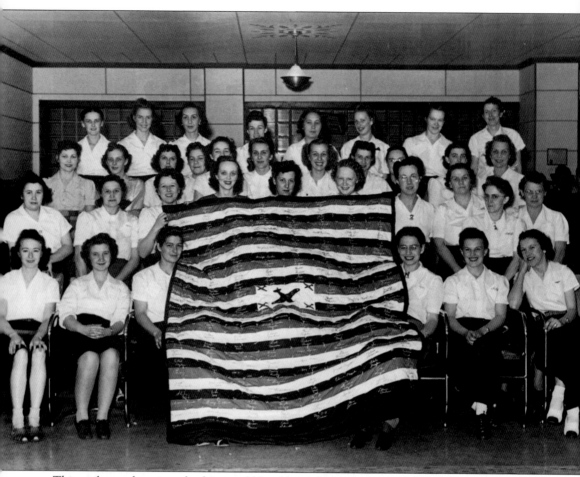

This quilt was done in red, white, and blue fabrics. It was embroidered with the names of those who bought a chance to win the quilt. The raffle netted $211.34 that was sent to the Department of War to help purchase a new bomber. The photograph was taken on December 5, 1942. Members of the Rockford bowling league that made the quilt are, from left to right, (first row) Betty Felter, Nadine Smith, Marion Vivins, Vera Paepke, Madeilene Burch, and Jo Lang; (second row) Marion Tompsett, Una Wilkinson, Doria Civils, Julia Holck, Ruth Paepke, Nellie Finch, Ella Mc Clery, Myrtle Burgy, Grace Daryl Rice, and Margaret Mac Iver; (third row) Margie Cole, Vivian Peterson, Janet Newcombe, Oriel Mathews, Gailey Beals, Jerry Schmitt, Francis Moldevee, Marjory Rector, Betty Wolven, Lois Pressor, and Marguerite Bertha Paepke; (fourth row) Marion Blossom, Martha Gedritis, Dorothy Schmidt, Barbara Spencer, Bertha Wingard, Elaine Smith, Louise Gibbs, and Theo Stauffer. (Rockford Area Historical Museum.)

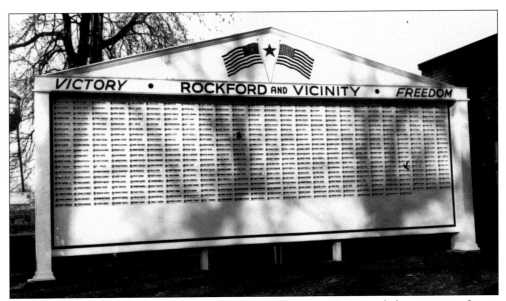

This World War II wall of honor lists 497 men and women who served their country. It was erected by the American Legion on the east side of the post office next to the Peppler Building, where it remained for several years. It is unclear what happened to it after it was removed. (Rockford Area Historical Museum.)

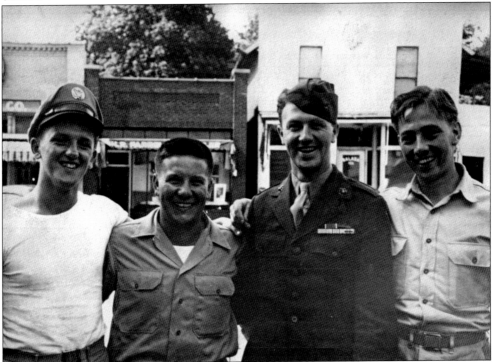

Everyone on the home front was relieved and happy that World War II finally ended. But the home folks were no happier than those who served the United States in battle. Four members of the Greatest Generation from Rockford are seen here. From left to right are George Newell, Ben Pratt, Ross Douglas, and Clayton Pine. (Rockford Area Historical Museum.)

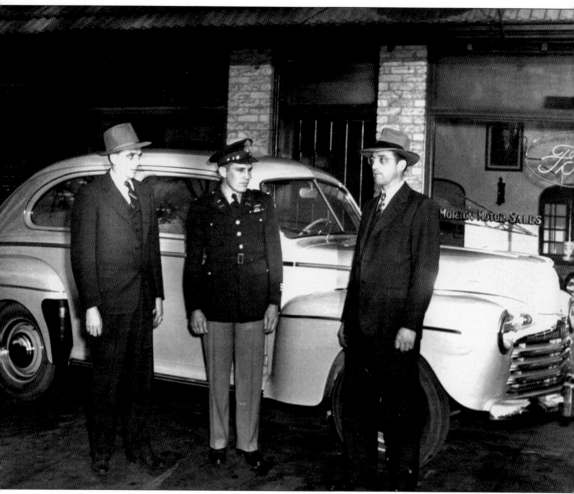

Maj. John C. Sjogren was a staff sergeant in the U.S. Army, Company I, 160th Infantry, 40th Infantry Division, and received the Medal of Honor for courage above and beyond the call of duty on October 12, 1945, from U.S. president Harry Truman. On November 1, 1945, Morton Ploeg (left), Rockford Ford dealership owner, and Melvin Baldwin, Rockford Chamber of Commerce president (right), present John Sjogren with a deluxe Ford sedan. Contributions for well-wishing friends and neighbors paid for it. It was one of the first vehicles off the assembly line. The 29-year-old soldier commented, "I am not only grateful but also embarrassed. So many of the men who did so much for their country never came back to receive such a gift." (Rockford Area Historical Museum.)

While fighting in the South Pacific, Lt. John C. Sjogren was credited with knocking out nine Japanese pillboxes and killing 43 enemy soldiers. Even though he was wounded himself, the lieutenant crossed 20 yards of exposed terrain to administer first aid to a wounded comrade. This courage under fire occurred after Lieutenant Sjogren had had difficulty enlisting and was originally classified 4-F. After having his tonsils removed, he tried again and was accepted. He took part in battles at Guadalcanal, Cape Gloucester, New Britain, and the Philippine invasion with the 40th Division. In addition to presenting their local Medal of Honor recipient with a new car, Rockford citizens also welcomed him home with a celebratory parade. (Rockford Area Historical Museum.)

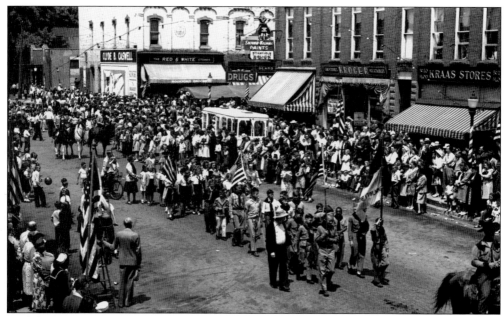

Rockford enthusiastically welcomed all its returning World War II servicemen back with a homecoming parade on June 15, 1946. A cheerful carnival atmosphere prevailed as everyone celebrated. The parade included Boy Scouts, Campfire Girls, horses wearing tooled leather tack, and marching bands. Parade watchers carried balloons, waved flags, and stood six deep as they watched Rockford's officers and enlisted men march past. Over 100 servicemen passed in review. Courtland Street was blocked off, and a viewing tent was erected for civic leaders to use. Popcorn, soft drinks, and other snacks were sold. These photographs were taken from the west side of Main Street looking northeast. (Rockford Area Historical Museum.)

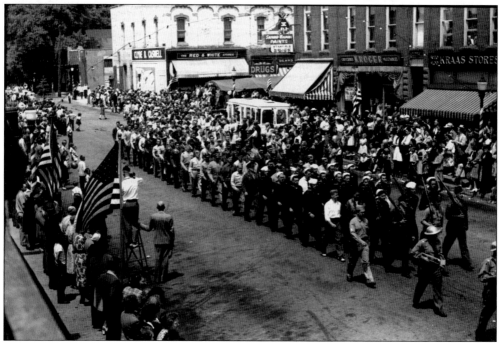

Six

PEOPLE

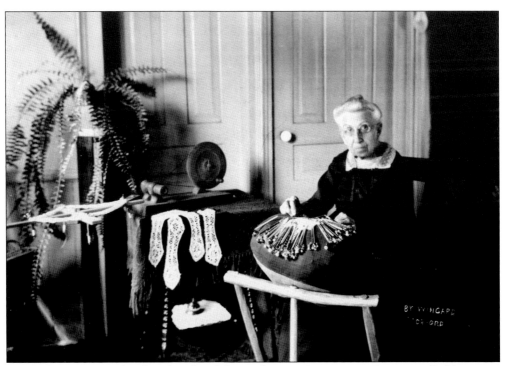

Elizabeth Pratt enjoyed making handmade lace in her own living room. A variety of bobbins were used in the process. She learned how to make lace in England, her country of birth. She came to America in 1893 and lived in a cottage on Fremont Street in the south end of Rockford with her husband, Jerry, and daughter Anna in the early 1900s. (Rockford Area Historical Museum.)

Amy Ann Lapham was born in 1831. In 1845, she became the first teacher in the Laphamville. Her husband Edward Piper operated the first public electric power plant for Del Tower and also owned the last sawmill in Rockford. This photograph was taken in 1910 when she was 79 years old. (Rockford Area Historical Museum.)

In 1871, Pres. Ulysses S. Grant appointed Judson M. Spore Rockford's first postmaster. He held that post until his death in 1910. His widow, Clara Dunton Spore, succeeded him in this position. Judson was a member of several community organizations, including Decker's Rockford Band, shown on the cover of this book. (Rockford Area Historical Museum.)

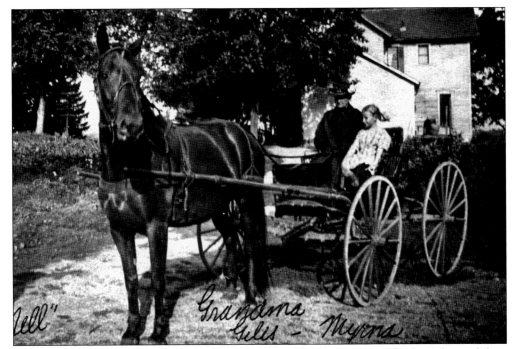

Grandma Phila Giles holds the reins of Nell the horse. Her husband was Charles Giles, and their granddaughter is Myrna, sitting with her grandmother in the wagon. Myrna's parents were Elwin and Cornelia A. Giles. (Vance Harger.)

Beginning in 1920, Clyde Reynolds spent 34 years working as a rural mail carrier. He married Amelia Peterson, and they had three children. The Reynolds family attended the United Methodist Church. Standing are, from left to right, Eloise, Clyde, Robert, and Lyle. Amelia is seated in front of them. (Rockford Area Historical Museum.)

This photograph of Dorthea Rector Spring, husband Albert Spring, and daughter Catherine was taken 1890. Catherine later married Willis C. Young. The picture was taken while they were still living in the homestead on Grass Lake in Cannon Township. Spring kept a daily diary from the 1870s until her death in the 1920s. It is available at the Grand Rapids Public Library Archives. (Rockford Area Historical Museum.)

Arden "Archie" Ives was born in 1888, the son of George and Alice Rounds Ives. In 1910, he married Lelia M. Rector. They had three children, Don, Arden, and Donna June. Don and Arden graduated from Rockford High School. In 1919, the family moved to its home on Summit Avenue. Don recalled, "Summitt Avenue was a muddy road with grass growing in the middle." (Rockford Area Historical Museum.)

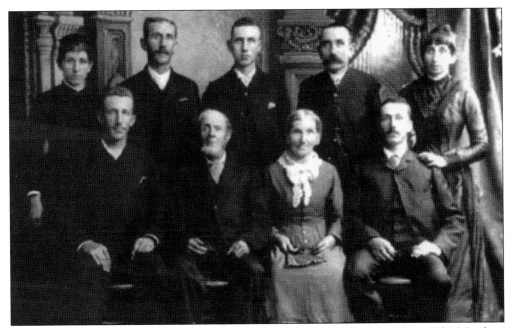

Gottleib Hessler was born in Germany about 1829 and his wife, Margaret, about 1854. Members of the Hessler family include, from left to right, (first row) Henry, Gottleib, Barbara, and William; (second row) Mary, George, Wesley, John, and Lena. Henry and Wesley built the Hessler Building in downtown Rockford. (Rockford Area Historical Museum.)

From left to right are Isabelle, Claude, and Matthew Hessler. Matthew was a lifelong resident of Courtland Township. He was born in 1861 and died in 1938. He married Isabelle Haffey in 1888. Claude married Evah Hough in 1915. Claude and his wife owned a farm in Courtland Township for many years. (Rockford Area Historical Museum.)

Robert Carlyle emigrated from Scotland with his parents in 1842. In 1852, Carlyle married Lucy Beers, and they had nine children, eight of whom survived to adulthood: Albert (who married Eliza Pierson), Henry (who married Eliza Frederickson), Emma, Harvey, William, Estelle (who married Frank O. Kelsey), Hattie (who married Wesley P. Baker), and Grace (who married Ross Squires in 1896). Carlyle served in the U.S. Navy during the Civil War. The family lived in Rockford for about 30 years, and he ran a grocery store. (Rockford Area Historical Museum.)

At right are the grandchildren of Robert and Lucy Carlyle. On the upper left is Roy Carlyle, son of Albert. Ethel Carlyle is on the lower left and is the daughter of Henry. On the upper right is Lena E. Baker, and on the lower right is Bernice J. Baker; they are both the daughters of Hattie and Wesley P. Baker. (Rockford Area Historical Museum.)

Charles and Nellie Winfield Ammerman are pictured in the photograph to the right. Below are four of their five children, with only William missing from the photograph. Charles worked a farm on the west side of the Rogue River. Their large well-appointed farmhouse still sits up the hill on the north side of Division Street (Ten Mile Road). In the photograph below are, from left to right, Dorothy, Laura, Gerald, and Lester. (Rockford Area Historical Museum.)

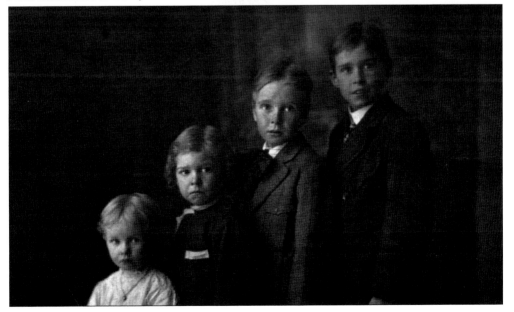

In the photograph to the left are, from left to right, Ray, Wayne, and Ruth Zimmerman. Their parents are Fred and May Zimmerman. As children, they grew up on a farm in Courtland Township. This photograph was taken about 1900. (Leigh Paull.)

These are three of John Frank and Lottie Aldrich Elkins's children. From left to right are Nettie, Arden (Ardie), and Louis Elkins. As an adult, Louis and his wife Faye lived on Sigsbee Street. Nettie married Art Cliff, and Arden married Noreen Norman. (Noreen Norman Elkins.)

From left to right are James Lewis (Lou) Blachly, Calla Estelle Blachly (Mrs. Harry Judson) Smith, Eloise Blachly (Mrs. Clarence) Graves, Lillian Estelle Weller Blachly, and Lula Blachly (Mrs. Willis) Souffrou. Lou Blachly was the son of Dr. Miller J. Blachly and Mary Elizabeth Graves. His wife, Lillian, was the daughter of Harvey H. Weller and Adeline DeEtta Spore. The Blachly and Weller names are well known near Brower Lake, as well as within Rockford. (Rockford Area Historical Museum.)

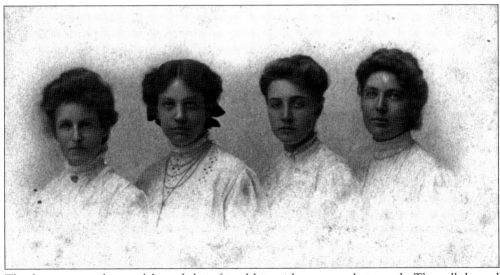

The four women above celebrated their friendship with a group photograph. They all dressed up in their Sunday best, wearing treasured jewelry. Pictured above are, from left to right, Olive Carlyle (Mrs. William) Kies, Nellie Kies (Mrs. Carl) Hyde, Ottilia Schumacher, and Louise Kies (Mrs. C. Evan) Johnson. (Helen Kies Uren Hessler.)

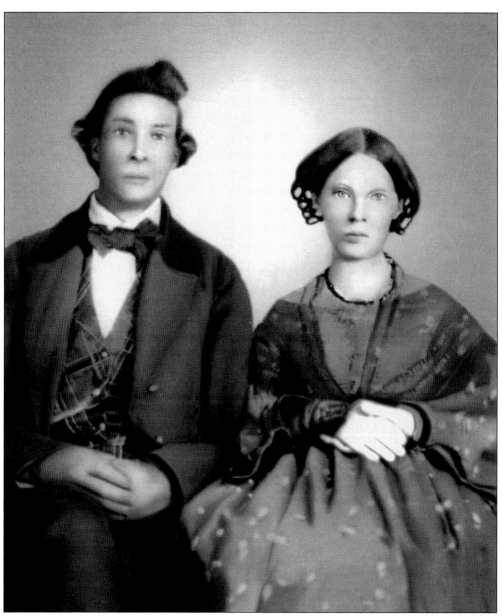

Harvey and Sarah Bailey Porter were married in 1845. In 1851, Harvey acquired the William Hunter house on the northeast corner of Main and Courtland Streets and converted it into Rockford's first hotel, the Algoma House. William Hunter and his brother Merlin were the first settlers to stay in Rockford. In 1864, Horatio Stinson purchased the Algoma House, only to have it burn down six weeks later. This was the first recorded fire in Laphamville/Rockford history. He then built a new hotel, logically named the Stinson House, on the same plot of land. (Willis Richard Bowman and Janet Matthews.)

On the right is a photograph of Grace Daryl Rice. She graduated from Rockford High School in 1923 and worked for the Wolverine Shoe Company for 10 years. She was a member Grand Rapids Society of Accountants. She was three years older than her sister Maizie Gail Rice. At a 1973 class reunion, she was described as being "always certain." For many years, Grace Daryl Rice lived with her sister on Courtland Drive. (Rockford Area Historical Museum.)

Maizie Gail Rice also graduated from Rockford High School in 1923. She was the class president. Following graduation, she worked for a construction company. In 1973, classmate Lucille Cranston noted that Rice was "a real nice girl." Maizie Gail and Grace Daryl Rice's parents were William and Minna Rice. The girls also had an older sister named Marvel. (Rockford Area Historical Museum.)

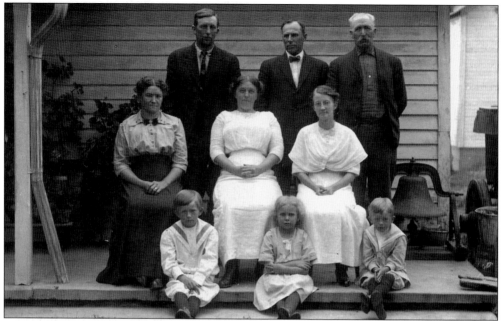

Whittall family members are depicted in this picture. Seen here are, from left to right, (first row) Roy Whittall, Ida Skrine Stacey, and Audly Whittall; (second row) Vera Whittall (wife of Ed), Gertrude Whittall Skrine (daughter of Ed and Vera), and Georgia Partridge Whittall (wife of Glen); (third row) Glen Whittall (son of Ed and Vera), William Skrine, and Ed Whittall. (Helen Kies Uren Hessler.)

This is the wedding photograph of Kenneth Nelson Weller and Lila Elizabeth McIntyre, from May 29, 1923. They had two daughters, Maxine Ruth and Joan Eleanor. He was employed at Wolverine Shoe Company for 37 years and was a member of the Masonic lodge. (Rockford Area Historical Museum.)

Otto Karl Spanenberg was born in 1898 in Grand Rapids. He graduated from Rockford High School and was very active on the football and track teams. He taught high school in Onaway and Redford. In 1965, he started what is now the North Kent Golf Course. He died in 1980 at his residence on Northland Drive. (Rockford Area Historical Museum.)

Dr. Hollis O. Sarber came to Rockford in 1881. He was a graduate of the Cincinnati Eclectic College and practiced medicine until his death in 1926. He was 69 years old. Dr. Sarber was considered to be "one of the grand old men of the community." He was survived by his wife, Ida May; a daughter, Wynne (Mrs. Clyde) Weller; and his grandson Rodney Weller. (Rockford Area Historical Museum.)

Myrna Giles was born in 1908, the daughter of Elwin and Cornelia A. Giles. She poses here wearing one of her best dresses. Her hairstyle is indicative of those worn by women around 1920. As an adult, she married Dallas Harger. (Terry Konkle.)

The cute little nine-month-old boy in the center of this photograph is Max Ingraham, son of Leonard and Ava Ingraham. The picture was taken in 1935. The two young girls with Max are not identified. The three children are seated on the grass on the southeast corner of Monroe and Courtland Streets. (Rockford Area Historical Museum.)

Like many young men, Harry Gaines loved to hunt and fish. He spent many hours with friends like Homer Burch casting bait into the Rogue River, hoping a hungry trout would bite. All of Rockford's avid anglers appreciate their close proximity to the river's fishery. (Ann Kubiak Milanowski.)

Four generations pose proudly together. Great-grandmother Anna Gotting holds her great-grandson Douglas Paull. Standing on the left is Douglas's mother, Coyla Zimmerman Paull. Emma Gotting Zimmerman, mother of Coyla, daughter of Anna, and grandmother to Douglas, stands on the right. (Leigh Paull.)

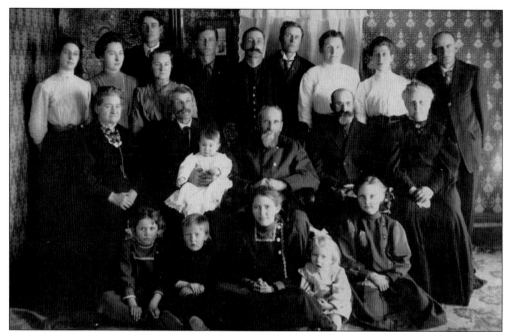

This photograph is of a Cowles family reunion. From left to right are (first row) Florence Cowles, S. B. Cowles, Hazel Cowles, Florence Sipple, and Ethel Sipple; (second row) Gladys Lutz, Volney Cowles holding Volney Lutz, Shepard Bates Cowles, Clifton Cowles, and Louise Cowles; (third row) Gladys Lutz, Cleo Cowles, Clifton Cowles, Minnie Cowles, Carey Cowles, Mason Cowles, Corwin Cowles, Greacie Storey Cowles, Florence Cowles Sipple, and John Sipple. (Rockford Area Historical Museum.)

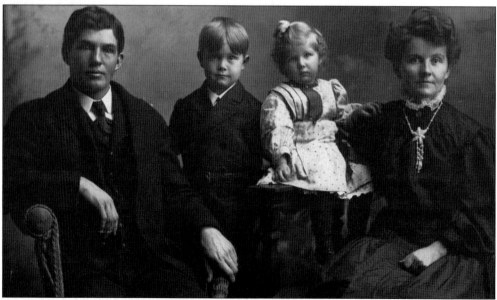

From left to right are Harlen H. Weller, son Louland Weller (born in 1903), daughter Edna Weller (born in 1906), and wife Lillian Brooks Weller. Harlen married Lillian in 1901. She was born in 1881, and he was born in 1876. Harlen was the son of Harvey and Adeline Weller. (Rockford Area Historical Museum.)

Jackson Coon married Emily Stout in 1860. They had six children. In the image above, Jackson Coon is standing in front of the family's home in a beard and hat. The house stands on the east side of Main Street across from Wolverine World Wide. The Coons had six children, Stella, Fred, Ada, Harriet, Hubert (Bert), and Bessie. They are not specifically identified in the photograph. The boy on the lawn is a neighbor, Louis Lamore. (Rockford Area Historical Museum.)

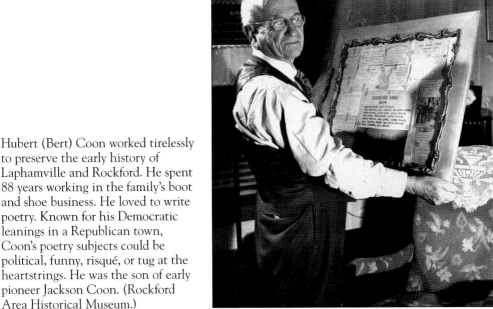

Hubert (Bert) Coon worked tirelessly to preserve the early history of Laphamville and Rockford. He spent 88 years working in the family's boot and shoe business. He loved to write poetry. Known for his Democratic leanings in a Republican town, Coon's poetry subjects could be political, funny, risqué, or tug at the heartstrings. He was the son of early pioneer Jackson Coon. (Rockford Area Historical Museum.)

For over 90 years, Clarence Blakeslee has been an avid historian and photographer. In 1989, he published some of his personal memories in *A Personal Account of WWII by Draftee #36887149*. It describes unglamorous life in the trenches rather than grand military strategies. After the war, he returned to Rockford and started his own mechanical contracting company. Blakeslee served as mayor and as a Kent County commissioner. (Rockford Area Historical Museum.)

Clarence and Lois Blakeslee were married for almost 60 years. A kind and gracious lady, she passed away in 1995. They had two sons, Neil on his father's knee and Rodd in Lois's lap. Lois was an avid gardener. Both sons grew up to be members of the Rockford City Council. Rodd joined his father in Blakeslee Heating and Cooling, and Neil became a lawyer. (Rockford Area Historical Museum.)

Homer Burch's primary interests in life were his family, the river, and local history. Following retirement, he dedicated much of his time to uncovering, preserving, and interpreting Rockford's past. His book, *From Sawmill to City*, was the first compiled history of the area. Burch was a veteran of the Mexican border war of 1916, World War I, and World War II. He and his wife of 48 years had one daughter, Virginia. (Rockford Area Historical Museum.)

Edward O'Brien was editor and owner of the *Rockford Register* from 1936 to 1965. He was born in Coral, where his father edited and printed the newspaper. In 1929, he came to Rockford and worked for Tom Johnson, the previous editor until O'Brien purchased the newspaper. Both O'Brien and his wife, Rose, were active in Rockford civic organizations. O'Brien passed away in 1985, and his wife died in 1981. They were survived by their son Edmund S. O'Brien of Greenville and their daughter Dorothy Gillespie of Alpena. (Rockford Area Historical Museum.)

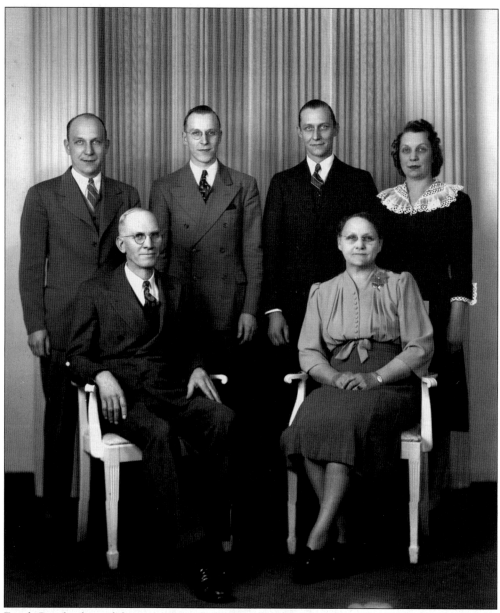

Frank Paepke farmed for many years before moving to Rockford in the 1930s. He worked for 8 years at the Rockford Co-operative Company and for 12 years at Wolverine World Wide before retiring 1954. Following retirement, he devoted time to his garden and doing odd jobs for local residents. Paepke was a member of the Silver Lake Grange and associated with the First Congregational Church of Rockford. He married Bertha Wilhelmina Beduhn in 1889. They had four children. In the photograph above, Frank and Bertha are seated. Standing are their children, from left to right, Arnold Henry, Edwin Charles, Leslie Frank, and Marguerite Bertha Paepke Frye Robbie. (Rockford Area Historical Museum.)

Dallas Harger and Myrna Giles were married in 1927. Dallas graduated from Albion College where he played on the football team. A banker, he enjoyed music and vintage automobiles. Myrna was a well-loved local librarian. Both were active in many civic organizations. Above are, from left to right, Myrna Harger, Dallas Harger, and son Vance Harger. (Vance Harger.)

The extended Kies family is pictured above. From left to right are (first row) Esther Church Van Haften, Dianne Uren Skiver, Bonita Boyd Braman, and Barbara Kies Willett; (second row) Fred Boyd, Grace Brayman, Olive Carlyle Kies, Dr. Robert Brayman, Ann Kies Church, William Kies, and Emma Wineberg; (third row) Helen Kies Uren Hessler, Kathryn Kies Boyd, Edith Johnson, and Lena Shotwell Kies; (fourth row) Carl Hyde, Charles Hyde, Henry Kies, Jerry Johnson, Jim Van Haften, and Charles Uren. (Helen Kies Uren Hessler.)

Hazel Marian Cowles (Mrs. Clarence Earl Beatty) is seated in this photograph. Shown standing are her daughter Marianne Beatty Montgomery (left) and granddaughter Megan Ann Montgomery. Hazel graduated from Ferris State College in 1929. She was a lifelong member of the Rockford Congregational Church, taught disabled children for over 40 years, and was honored by the National Organization of Women for work to advance women's rights. (Rockford Area Historical Museum.)

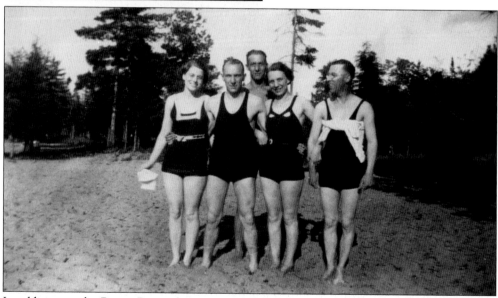

In addition to the Rogue River, the greater Rockford area is blessed with a number of quality recreational lakes. Fishing and swimming have always been common pastimes for local residents. However, bathing attire has changed drastically from that worn in the 1930s and 1940s. From left to right are Vera Paepke, Arnold Henry Paepke, Leslie Frank Paepke, Marguerite Bertha Paepke Frye, and William Frye. (Pat Frye.)

The photograph at right of Dr. Gerald De Maagd was taken in 1933. He graduated from the University of Michigan Medical School in 1929 and began practicing in Rockford the next year. As well as memberships in the National Academy of General Practitioners and the Kent County Medical Society, he served as a deacon for the First Congregational Church and on the school board for nine years. (Rockford Area Historical Museum.)

The Dr. Gerald De Maagd family is pictured in the photograph above. Sue is standing in front, with, from left to right, Gerald, Pat, Gertrude, and Jerry in the back. They are dressed in early spring finery, celebrating the Easter holiday. Dr. De Maagd met his wife Gordelia (Gertrude) Kleinseksel when she was in nursing school. They married in 1934. (Rockford Area Historical Museum.)

Donald Hunting was the only child of Barton D. Hunting and Pearl Sipples. He was born in 1902. His father was killed in a railroad accident when Donald was 14. Donald married Florence Pittenger in 1928, with Richard Krause acting as best man and Otto A. Krause and his wife Henrietta as master and mistress of ceremonies. Donald spent many years working at the Wolverine Shoe Company. (Rockford Area Historical Museum.)

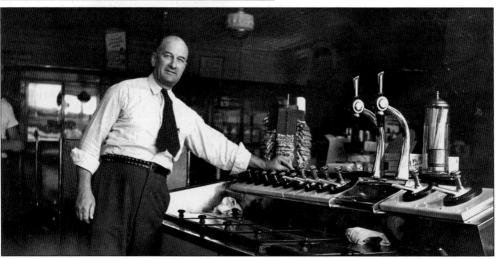

For many years, Milton Patrick was the owner of Patrick's Drug Store. It was located on the northwestern corner of Main and Courtland Streets. The all-inclusive soda fountain was patronized by young and old as they consumed malteds, sundaes, and cherry Cokes during the 1940s and 1950s. Patrick was a well-known figure in the community. (Rockford Area Historical Museum.)

The earliest Bailey arrived in Laphamville in 1847. Some 100 years later, in 1949, Bailey descendants gathered together. Seen here are, from left to right, (first row) Louis Bailey, Beulah Bailey, Lydia Hill, Lizzie Bailey, Lyndia Dunn, and Earl Dunn; (second row) Harold Bailey, Crystal Bailey, Marvin Hill, Thelma Bailey, and Howard Bailey. Harold was a machinist by trade, retiring from Kirkhoff Manufacturing in 1969. He is also affectionately remembered for his contribution to a local landmark. At the end of Prohibition in the 1930s, when Carl Hyde wanted a beer license for his pool hall, Hyde, Harold, Harold's older brother Howard, and former army cook and local barber George Myers developed the secret sauce that made Hyde's Hot Dog, which helped put the Corner Bar in Rockford on the map. (Rockford Area Historical Museum.)

The photograph above is of the extended Kies family. From left to right are William Kies, Olive Carlyle, Clarence Schumacher, Evan Johnson, Kathryn Kies Boyd, Ferris Church, Edith Johnson, unidentified, Fred Boyd, Carl Hyde, Louise Johnson, Grace Brayman, Lena Shotwell Kies, Henry Kies, Annie Schumacher, and Ann Kies Church. The picture was taken in the late 1930s. (Helen Kies Uren Hessler.)

The children of Stephan J. and Albreata Paull gathered together to have a good time. From left to right, they are Alvin Paull, Mary Paull, Don Paull, Mildred Opie Paull, Wilfred (Bill) Paull, Gordon Paull, and Wayne Paull. (Leigh Paull.)

C. Glen and Ada McBride arrived in Rockford in 1914. They opened the first grocery store on Main Street next to the building that now houses the Corner Bar. During World War II, Ada expanded the variety of goods offered while her husband served his country. After the war, Ada opened a gift shop at 119 Courtland Street. Later he closed the grocery, and they operated McBride's together until 1973. (Rockford Area Historical Museum.)

For many years, Lenna M. Wainwright Jensen operated Jensen's Beauty Shop on Courtland Street. Lenna was born in 1905 in Ensley Center. Her husband, Earle, began working for Wolverine Shoe and Tanning Corporation in 1927. At one time, he was responsible for finishing soles at factory A in Rockford. Both were very active in community organizations. (Rockford Area Historical Museum.)

125

This photograph records a Krause family Christmas gathering in the 1940s. From left to right are (first row) Nancy Knowlton Byram, Shirley Krause Ziegler, Jill Krause Ziegler, Jack Adolph Krause, unidentified, and Norma Knowlton; (second row) Bill Warren, Betty Bloomer Warren, Lee Warren, Janet Seven Krause, Adolph Karl Krause, Gertrude Seven Grebel, Knox Knowlton, and Jannette Seven Knowlton. Standing in the back are Earl Warren (left) and Jay Grebel. Adolph Karl Krause was a mainstay in the administration of the Wolverine Shoe Company. Following her divorce, Betty Bloomer married a young member of the U.S. House of Representatives named Gerald R. Ford. He later went on to be president of the United States. (Rockford Area Historical Museum.)

The Rockford Area Historical Museum was established by the Rockford Area Historical Society in 1976. The museum includes tools, toys, and furnishings from the 19th and early 20th centuries. A Victorian parlor, a 1920s office, and a rural mail carrier's buggy may be viewed there. An extension was constructed using federal and matching funds. The Homer L. Burch Room stores genealogical and local history papers and is open by appointment for researchers. The museum is located on Bridge Street, between the double dam and Squires Street. (Rockford Area Historical Museum.)

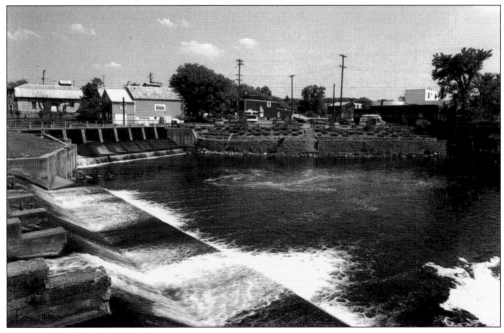

ACROSS AMERICA, PEOPLE ARE DISCOVERING
SOMETHING WONDERFUL. *THEIR HERITAGE.*

Arcadia Publishing is the leading local history publisher in the United States. With more than 3,000 titles in print and hundreds of new titles released every year, Arcadia has extensive specialized experience chronicling the history of communities and celebrating America's hidden stories, bringing to life the people, places, and events from the past. To discover the history of other communities across the nation, please visit:

www.arcadiapublishing.com

Customized search tools allow you to find regional history books about the town where you grew up, the cities where your friends and family live, the town where your parents met, or even that retirement spot you've been dreaming about.